I prefer looking at art alone.
When I'm looking at art with
someone else I feel like I'm
faking.

No...maybe...no...I love
this but it's been done so many
times. This could be ok. This is
perfect. How to...maybe my
arms like...or kneeling...yeah
that's good.

What did you think of the
exhibition? The paintings were
nice, but the gallery assistant
with the cool hair was snobby.
Let's sit outside, they have
benches. It would be nicer in
direct sun, but it's fun to watch
people.
Does Ai Wei Wei live in your
street? Who? Ai Wei Wei, the
Chinese artist. Oh yeh, him,
I don't know.

I'LL RIDE TO THE GALLERY AND WEAR
MY BLACK LEATHER COAT LIKE I
USUALLY DO.
MY BLACK SCARF AND DENIM JEANS.
MY WIFE THINKS IT'S COLD TODAY,
SHE'S RIGHT.

KubaParis
BonBock

Hard & Soft

@ Agora

Tapenade duo

Kohlrabi leaf and Beetroot almond Tepenades

with seasonal pickled vegetables
on Bedouin bread plate.

Palate cleanse

Rice noodles with Rhubarb, thyme, black pepper
and salt sorbet.

Main

Poached cod with crispy anise smoked pork belly accompanied
by roasted fennel, asparagus,

carrot, potato and onion

With self serve drizzled sauces of spicy plum, minted yoghurt,

and cashew miso.

Dessert
Mother's milk curd with tapioca pearls

and maracuja.

Hanna Stiegeler
"Untitled"

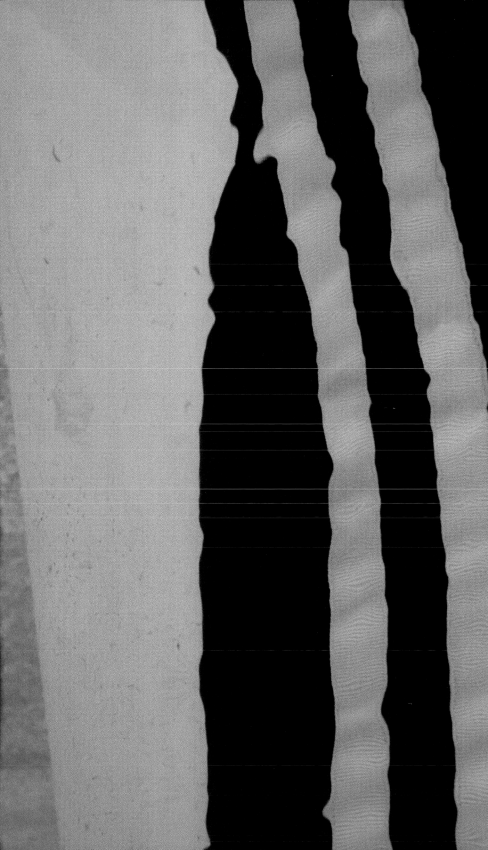

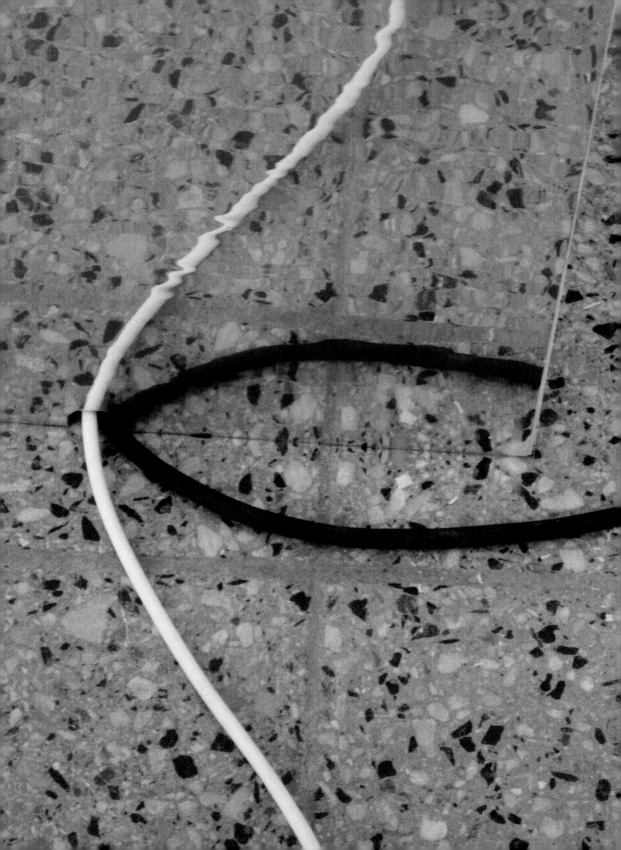

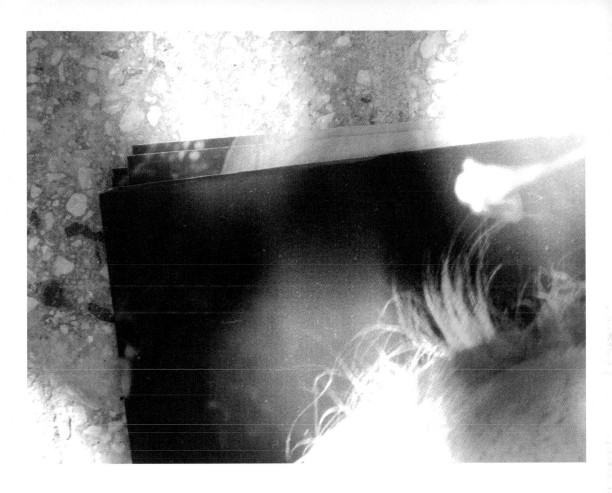

Body on view

my pants are in the mirror. They're adidas
but they're not. They're 100% pure expensive
polyester. Still, they don't fulfill an image
but become their own reminiscent identity.
Their distortion is prime. My distortion
is a prime act of autoeroticism. I'm fully there.
I'm the body in the exhibition, the pants in the
mirror. Hmmm. No one cares if I lie on the floor
and wrap my legs around the silver pedestal.

Merge!

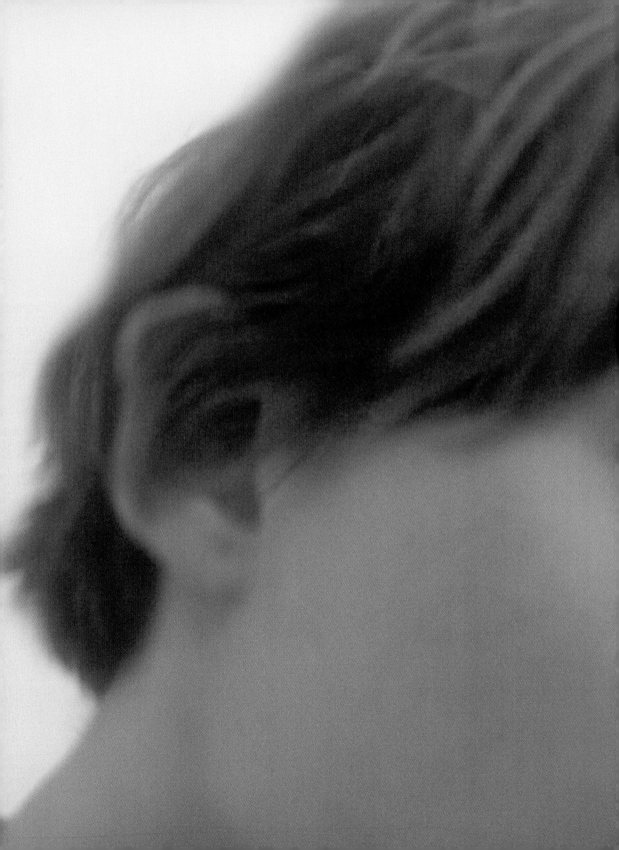

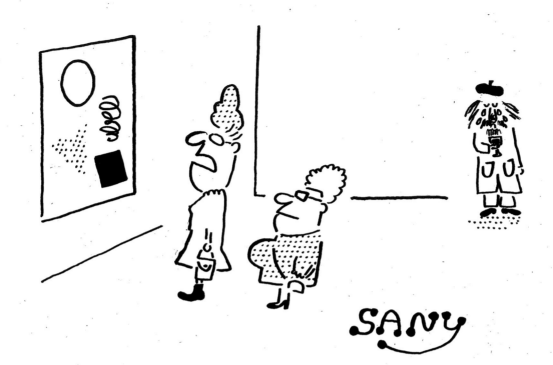

—CRAP, CRAP, CRAP!

-Less IS more...

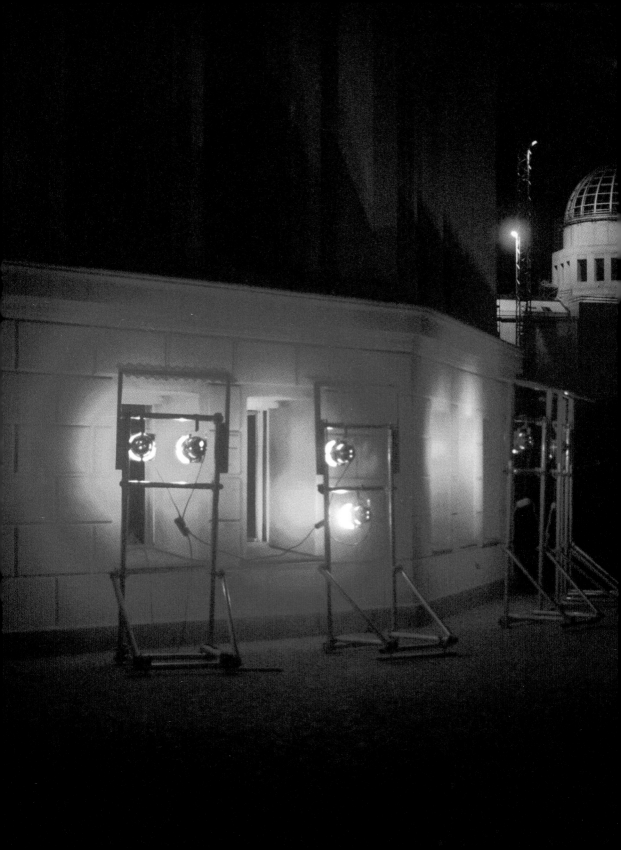

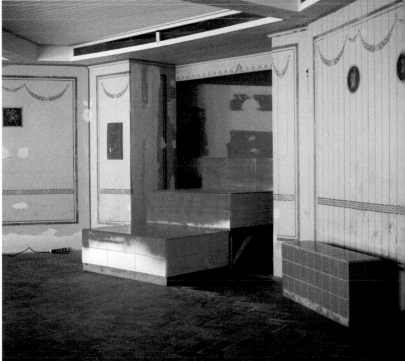

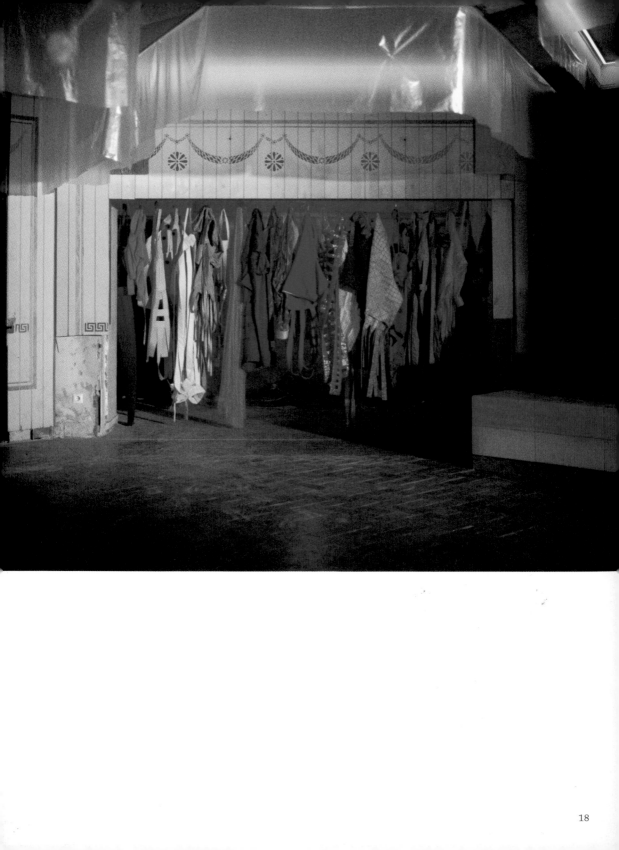

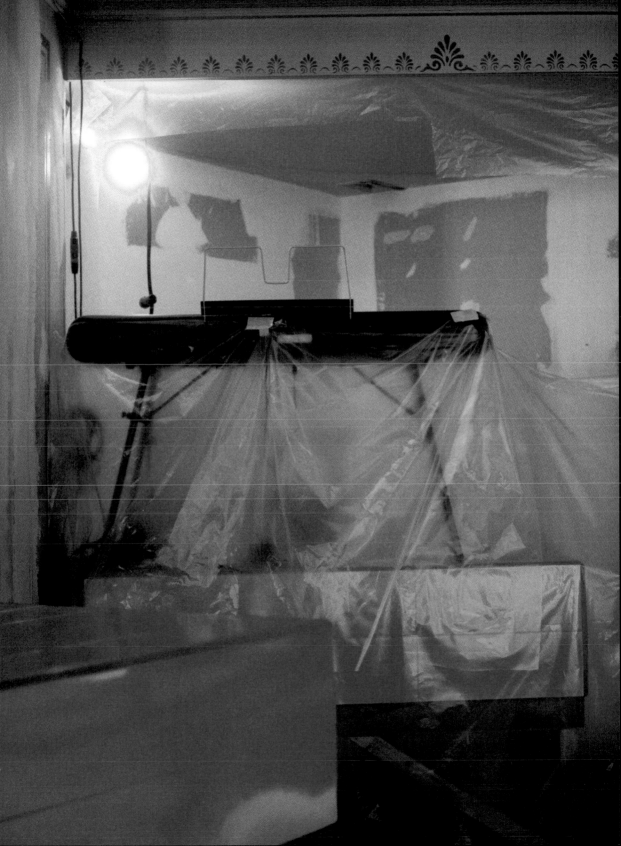

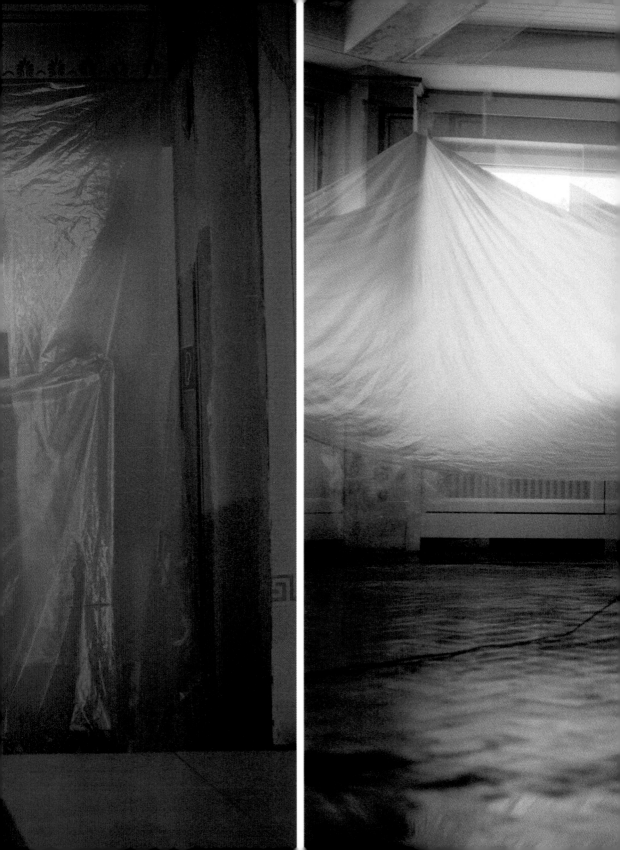

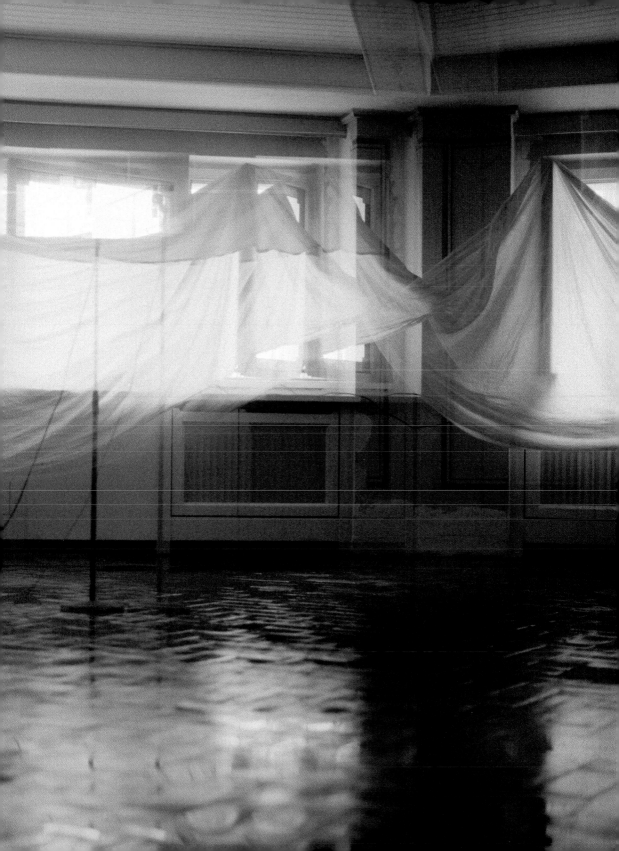

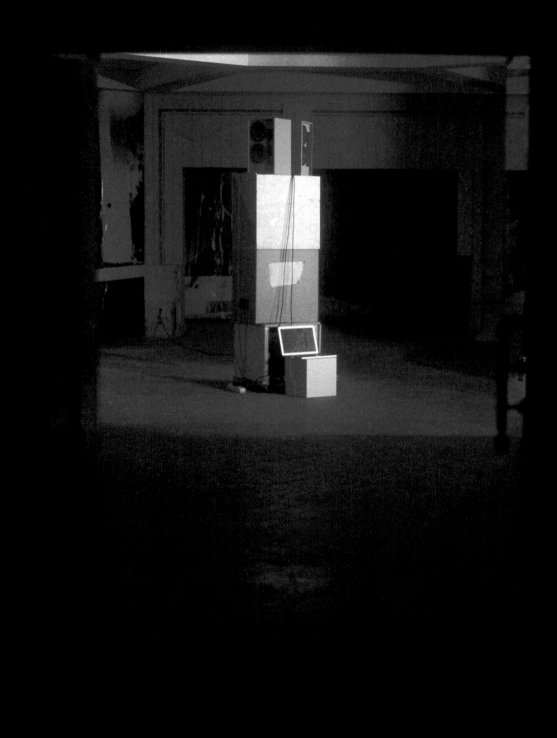

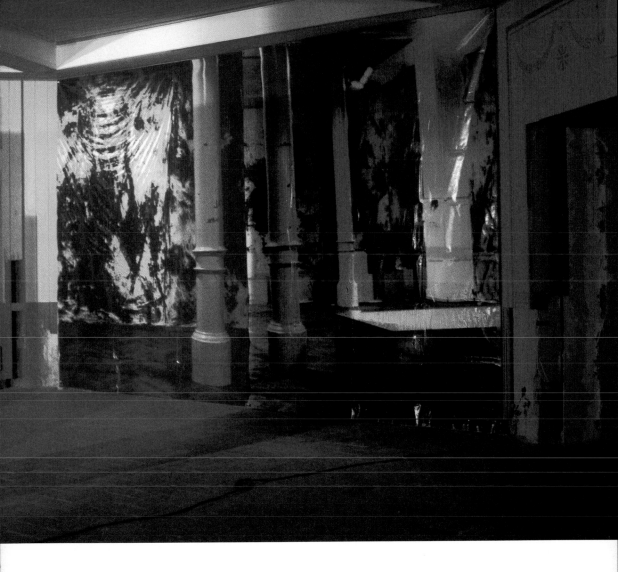

Calla Henkel &
Max Pitegoff
"Schinkel Klause"

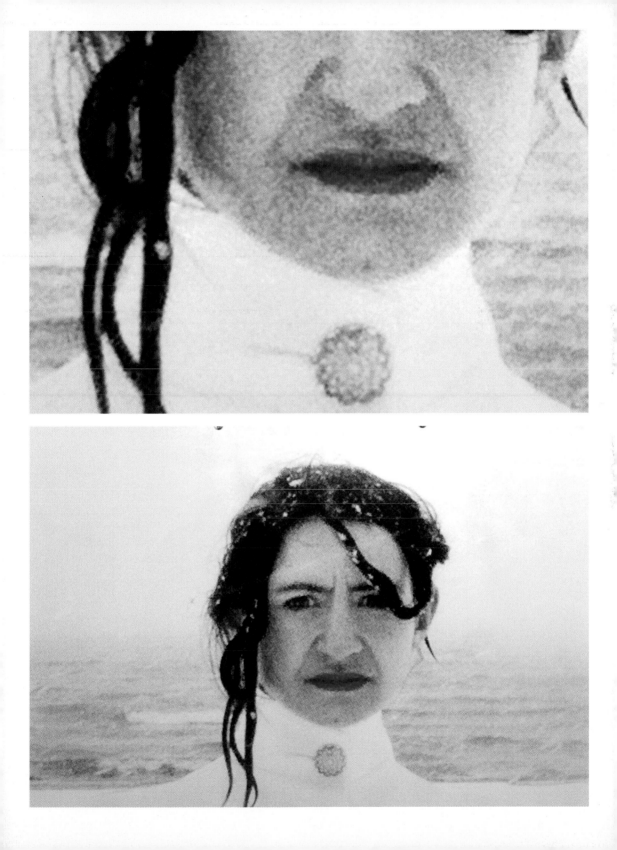

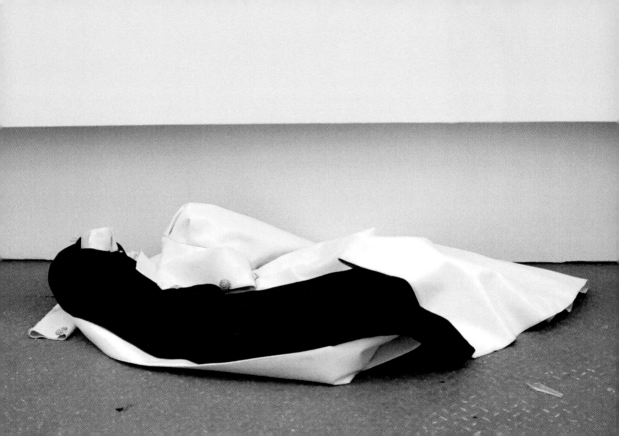

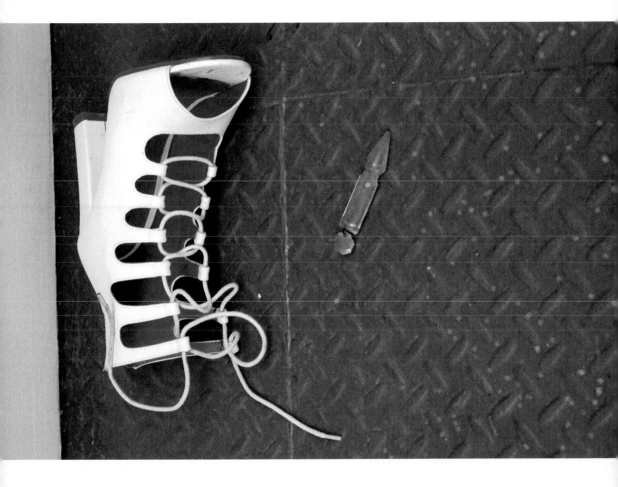

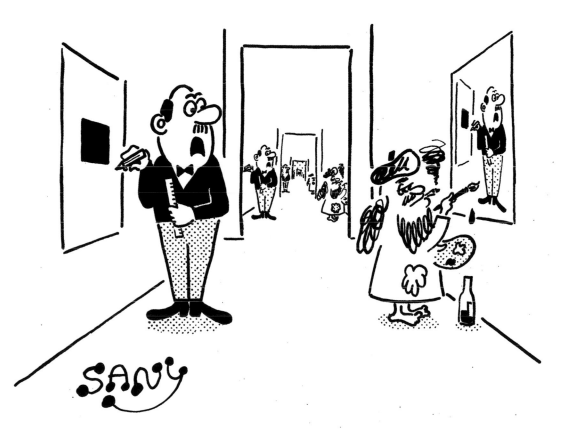

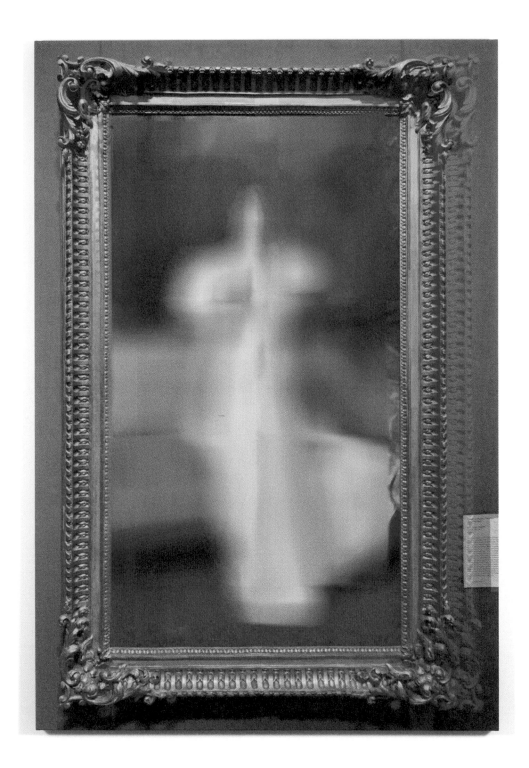

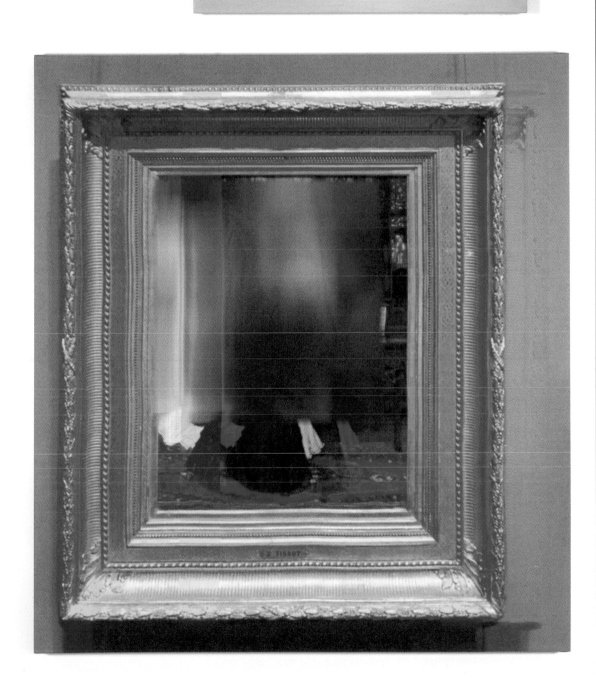

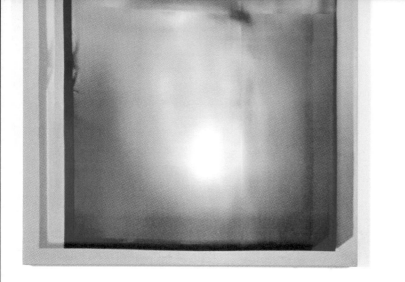

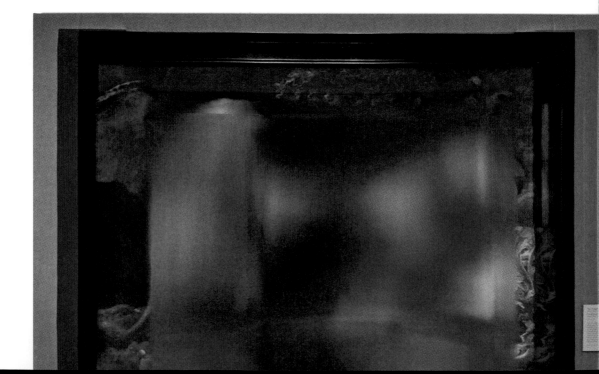

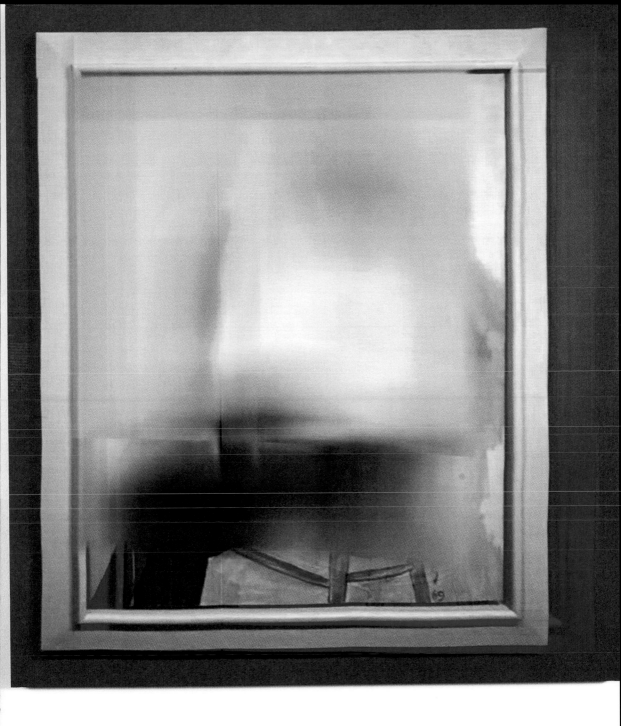

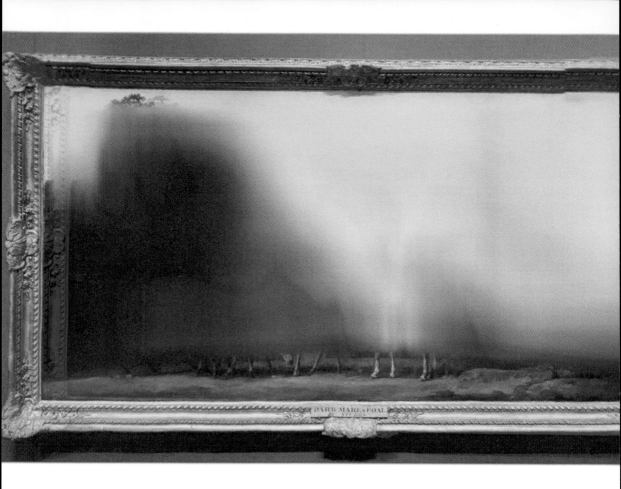

BARB MARE & FOAL

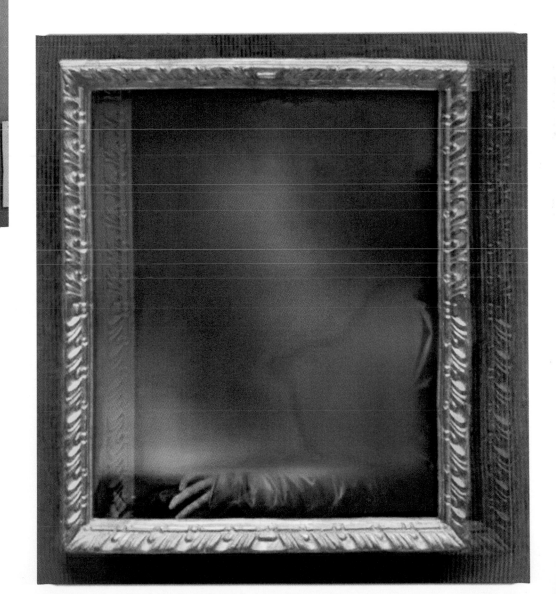

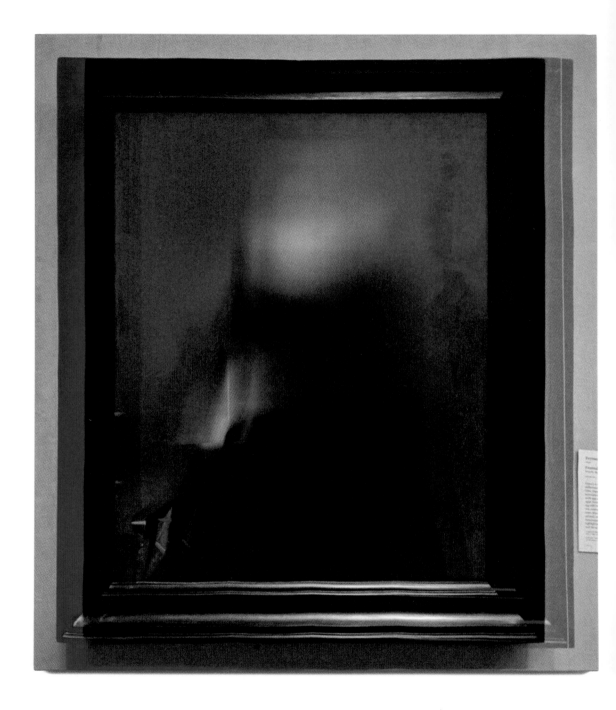

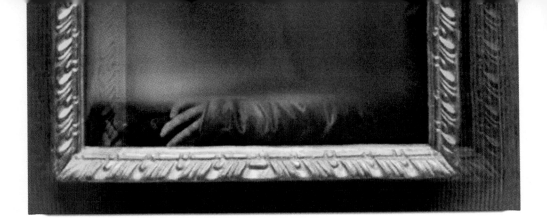

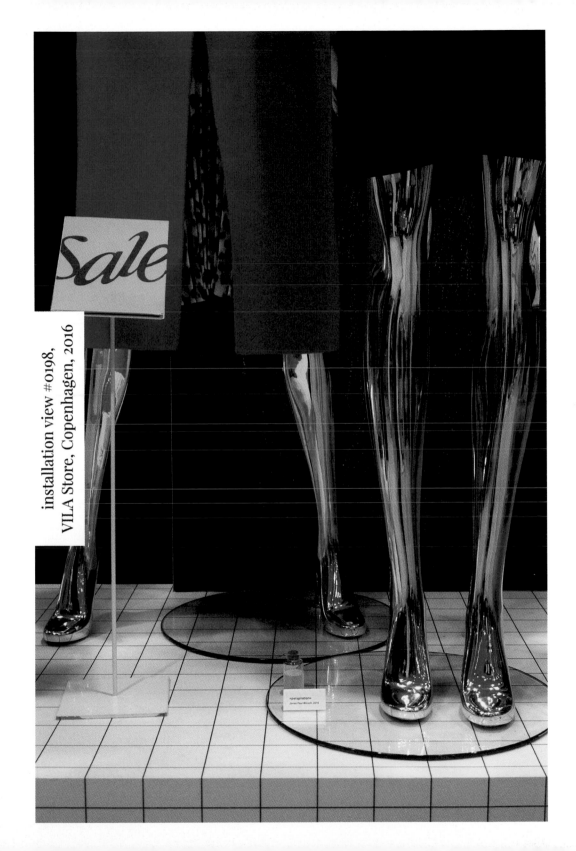

installation view #0198,
VILA Store, Copenhagen, 2016

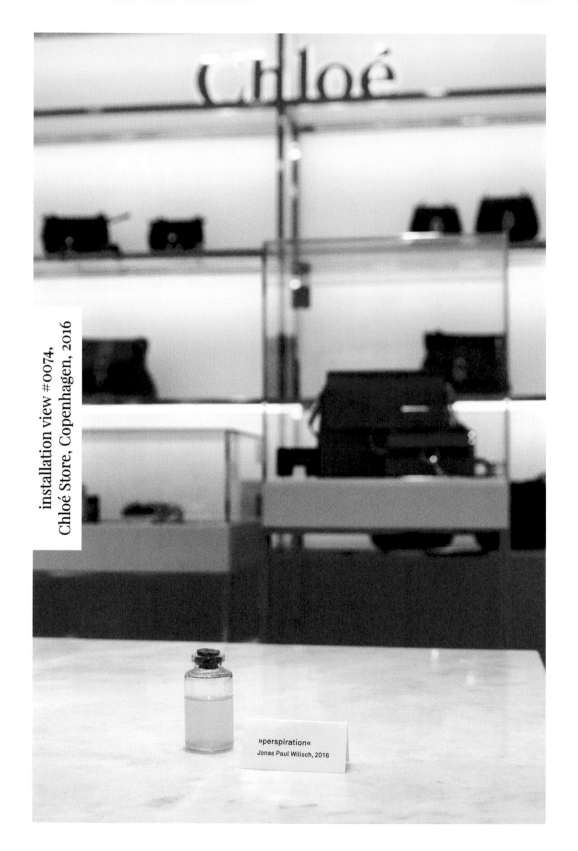

installation view #0074,
Chloé Store, Copenhagen, 2016

»perspiration«
Jonas Paul Wilisch, 2016

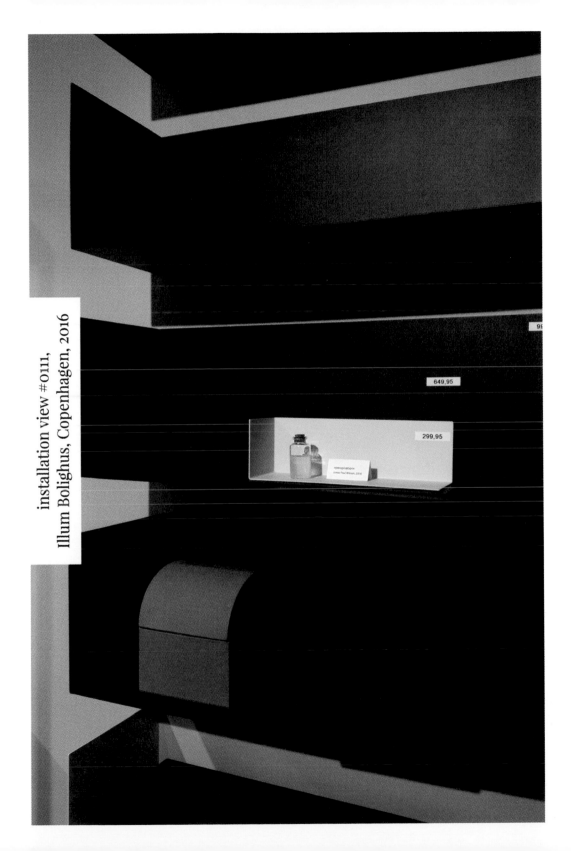

installation view #0111,
Illum Bolighus, Copenhagen, 2016

99

649,95

299,95

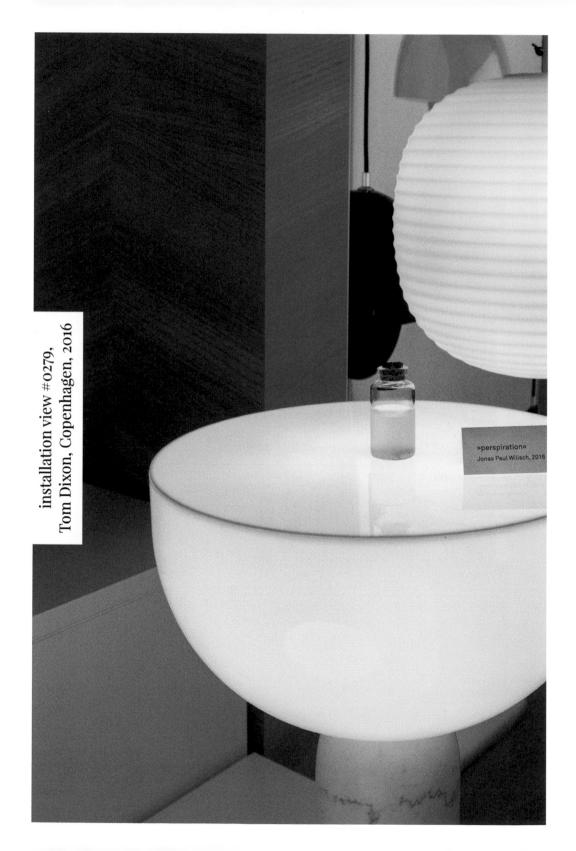

installation view #0279,
Tom Dixon, Copenhagen, 2016

»perspiration«
Jonas Paul Wilisch, 2016

Jonas Paul Wilisch
"the work: a series of
installation views"

Artworks

Jasmin Werner
Observational Games

For *Observational Games* (2016), Jasmin Werner instructed critics and curators to create fictional narratives based on observations gathered during visits to museums or galleries. The resulting texts were then given to a studio specializing in handwriting fonts. Each fictional character was associated with a font chosen by the artist, printed on cards, and presented at a dinner party during Gallery Weekend Berlin. The cards question how the individual experience of seeing art can be played through different instances of alienation and standardization. Jasmin Werner thus initiated a process of de-subjectification—from her subjective artist perspective. Pp. 1-5, 80

Hanna Stiegeler
Untitled

The details Hanna Stiegeler captures in *Untitled* (2015) seem to dissolve into opacity. Her gaze transforms the exhibition *ON VIEW* at KV—Kunstverein Leipzig into a visual scenario of blurred lines and reflective surfaces. In response to the exhibition, which, realized by A.R. practice in 2015, centered on interferences of physical and digital re-/presentation, the photographs articulate an alternative to the standardized imagery of the installation view. Pushing her own subjectivity against the limits of the spatial structure, Stiegeler not only makes edges and corners shake, melt, and disperse, but focuses precisely on the hidden details of an exhibition's visibility beyond its bright display. Her body serves as scale from which the exhibition is seen—and further reflected. Thus, the images rather serve as a materialized imprint of the artist's physical presence than an objective presentation of her view, merging her own presence, perspective, and space. Pp. 6-13

SANY
Acting Untitled

In most cases, exhibitions are viewed by visitors, reviewed by critics, and documented by photographers. All these situations seek to establish a rational, factual, or sophisticated understanding of what is on view. SANY (Samuel Nyholm) reflects this ambition in his drawings, which exist as banal, fictional situations amidst the bastions of high culture. They turn viewing exhibitions into a humorous act, a situation that parodies the exhibition visit as a staged performance itself, revealing prejudices, misunderstandings, and misinterpretations. Pp. 14-15, 31, 49, 68

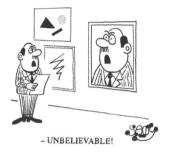

Calla Henkel & Max Pitegoff
Schinkel Klause

The images from the exhibition *Schinkel Klause* (2016) could be read as mere documentation of an event series at Berlin's Schinkel Pavillon between March and May 2016. In fact, they look at the transformation of the actual exhibition space—by highlighting it as a stage in flux. Calla Henkel and Max Pitegoff intertwine their role as artists with their interim use of the exhibition space, including its various historical and architectural layers. The actual happening is absent, but the images seem to hide a hint of aura, which is covered and reflected by a multitude of curtains, headlights, boxes, and sheets. The pictures not only bear witness to the moment before the exhibition space was renovated,

but also reflect an artistic practice that understands event, stage, space, and image as one unit. Pp. 16-23

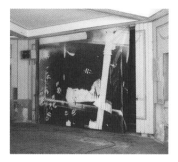

João Enxuto & Erica Love
Anonymous Paintings

João Enxuto & Erica Love's series *Anonymous Paintings* (2011–) can be seen as a reverse translation process: They transform digitized artworks back into three-dimensional inkjet prints. Using images of paintings from Google Art Project's (now called Google Arts & Culture) virtual, immersive and yet panoptic exhibition tours that have been blurred due to copyright restrictions, the duo then presents the prints stretched onto wooden stretcher bars in physical space. Enxuto & Love use this regulative view of an all-pervading power system to highlight its opacities, using the resulting art works to materialize censorship through multilayered, alienated, and unrecognizable aesthetics. In doing so, their view on exhibitions updates artistic institutional critique for the digital age and its shifting technologies. Pp. 32-39

Jonas Paul Wilisch's photo series *the work: a series of installation views* (2016/2017) takes the installation view as title and starting point. The work consists of a range of installation views that have been photographed as part of an intervention in Danish luxury shops. Where high-caliber value and uniqueness is displayed through expensive, desirable goods, Wilisch subtly inserts a small glass flacon along with a title label that reads "perspiration, Jonas Paul Wilisch 2016." As the flacon contains nothing but the artist's sweat, it confronts the aura of uniqueness with the actual labor it is made of. The resulting images show the paradox systems of value and labor that are embedded in every installation view, criticizing the use of the artist's subjectivity as a commercial item within a system of symbolic display. Pp. 41–45

installation view #0008,
Illum Bolighus, Copenhagen, 2016

New Noveta / Yair Oelbaum
Violent Amurg

New Noveta's show *Violent Amurg* (2017) at Ludlow 38 began with a performance, after which the leftovers where scattered throughout the exhibition space. Instead of staged artworks, then, the exhibition was comprised of a seemingly random arrangement of shoes, jackets, speakers, and ropes, combined with posters of the artist duo itself. The show did not represent a version of the past performance though, but re-created a sense of 'liveness' through the multilayeredness of the exhibition experience itself and the actors attached to it. Collaborating with photographer Yair Oelbaum thus meant to treat the images not as documentation, but as yet another aspect of an overall experience that scratched the silent, thick walls of the White Cube—stimulating and exposing its performativity through various media. Pp. 24–29

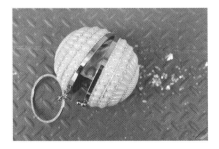

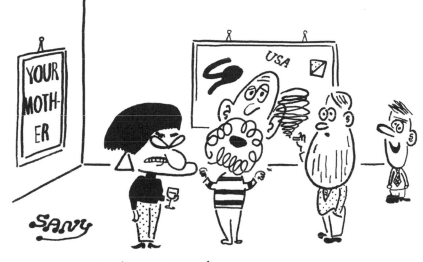

—Well, the show is not great,
but the crowd is a disaster!

Introduction

Seeing an exhibition does not necessarily equal a physical visit on site. It is rather the digital circulation that makes the exhibition view diffuse optically, technically, and culturally. How does this form of digitized visibility affect the personal view of exhibitions? How does it echo a new understanding of subjectivity? Exhibitions are not only documented digitally, but are actively staged together with their digital doppelgangers, such as when artists and museums use exhibition views to woo visitors. Exhibitions and works of art are also experienced digitally: The *Mona Lisa* is no longer just one of the most famous icons in the history of occidental painting, but also an icon of social media. In fact, digital documentation is closely intertwined with physical space and the liveness of events taking place in it. So when the exhibition starts to live in digital space, it becomes a new protagonist for different participants and practices that are not necessarily digital themselves. But documented as image, its view is defined by coding and technical parameters. It depicts the paradox between the perception of a unique, individual event and its regulated, standardized documentation online. The exhibition view has thus gained its own agency in a post-digital cultural environment, embedded in a constant interplay between cyberspace and 'real' space.

> Alongside this technological setting, the idea of subjectivity undergoes a moment of transformation. One can no longer objectively speak about digital media, but can only speak from an entangled, supposedly subjective perspective *within* media. Accordingly, there is a systemic crisis shaking the present, which questions the idea of the independent subject. Metadata and algorithms are both tracking and shaping the individual usage of technology. These computational parameters create subjectivity by displaying actions and connections of individual profiles, feeding them into a networked view. This kind of 'entangled subjectivity' is most clearly reflected in the artist's perspective today. Artistic expressions cannot only be seen as gestures of originality and uniqueness any more. They are rather embedded in a multilayered system of display, both interlaced and conflicted with curatorial, economic, and technological aspects.

Oscillating between concepts of individuality and standardization, this publication reflects its own role as an intermediary between exhibiting and publishing. In doing so, it highlights the transformation of cultural manifestations and its spaces of representation—and the individual experience

of these transformations through the lens of the digital. A significant pre-decessor for this publication was A.R. practice's project *ON VIEW. Interfer-ences of digital and physical re-/presentations*. Taking place in 2015 with artists Timo Hinze, Julian Irlinger,

Hanne Lippard, Falke Pisano,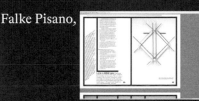

and Rebecca Stephany,

it put the relationship between exhibitions and their digital availability in perspective. It looked at whether exhibitions can still be considered from an autonomous view—or whether the faces of online image circulation cre-ated their own perspective. Consequently, the show first opened online and was then shown at KV—Kunstverein Leipzig

as a (re-)interpretation of the works on the web and its subsequent view in space.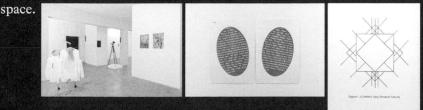

The publication *Echoing Exhibition Views. Subjectivity in Post-Digital Times* represents the next step in the process of transferring the exhibi-tion into different media—now occupying the space and materiality of a book. Again, it takes the view of exhibitions as a starting point. However, it embeds this topic into its material and technical preconditions, asking

for their potentials of transformation and translation. Thus, the printing process itself depicts an integral part of the publication's appearance. Printed with three special colors—Red, Green, and Blue (RGB), which refer to the color model used for image display on electronic screens—the publication plays with a color conversion that addresses connections between the digital and analog spheres. As a consequence, the images differ slightly from their original appearance, leaving an uncanny feeling that is discussed on different levels: in the texts, the artworks, and the book itself as a further medium of both presentation and representation. The appearance of the publication reflects the cultural modulation of subjectivity and its relation to digital display on the one hand, and makes the associated functionality, economies, and technological preconditions become part of its own design principle on the other. *Echoing Exhibition Views. Subjectivity in Post-Digital Times* can thus be seen as an attempt to imagine a contemporary view on medium and format: as a relational setting in flux.

So what is at stake when an exhibition circulates as a digital view? And how does its digital presence in turn affect and transform the subjective experience of seeing a physical exhibition? *Echoing Exhibition Views. Subjectivity in Post-Digital Times* gathers artists and writers that frame these questions through a variety of practices. It presents positions that have so far been shown infrequently or only in other contexts. They do not necessarily focus on digitality, but on a variety of media and practices that emerge from digital availability. With the work *Violent Amurg* (2017), the duo New Noveta staged a performance, the liveness of which resonates in the photographs by Yair Oelbaum, which he took after the actual performance as variation of typical exhibition views. The objects in the space—which had been used within the performance—thus represent more than a trace or a remnant, but become independent actors in the picture.

Hanna Stiegeler photographed the A.R. practice exhibition *ON VIEW* in Leipzig in June 2015. Her view on the show merges with the architecture of the space in a fluid, self-referential way, turning the visit into a new artwork.

João Enxuto & Erica Love's *Anonymous Paintings* describe how censored paintings from Google's virtual museum tour Google Art Project (now called Google Arts & Culture) can be translated from the digital medium back into the exhibition space—showing both its inscription of power and technology.

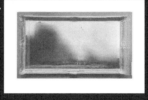

In 2016, the artist duo Calla Henkel and Max Pitegoff transformed Berlin's Schinkel Pavilion into the stage for a performance program they initiated with their work *Schinkel Klause*—

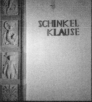

and then photographically documented this specially designed stage situation and turned it into another piece of work. In *the work: a series of installation views* (2016/2017), Jonas Paul Wilisch presents photographs of interventions he made in the shop windows of luxury brand stores.

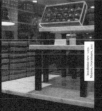

By treating these arrangements as a type of exhibition view, he highlights the commercial aspect of this form of documentation. Jasmin Werner's *Observational Games* (2015) can be seen as a conceptual approach to the exhibition visit: Her instructions for art professionals to write down their subjective experience while seeing a show were standardized through a workshop for handwriting and shown as texts of fictional personas on a gallery dinner table.

Likewise, cartoonist SANY documents views of exhibitions through the fictional, slapstick-like scenes in his drawings.

—Hi! I'm basically naked.

Within her text *In Other Words, Please be True*, Melanie Bühler links the installation view with selfie photography in order to examine them as subjective gestures. In *Professionalized Re-enactment*, artist Erika Landström discusses the relation of performance art to its digital documentation and circulation, and critically looks at forms of subjectivity arising through the effects of this circulation—as well as the values negotiated therein. In turn, *Subjective Exposure* by Agnieszka Roguski relates the concept of the creative subject to current strategies of presentation and reception of art in the web, as well as to forms of capital, which rely on networked publics. With this spectrum of contributions, the publication discusses the potential of subjectivity in times of digital regulation. The installation view thus reveals new perspectives on supposedly similar views.

Our special thanks goes to all the artists and authors for their contributions and collaboration, as well as to the artists who took part in the development process of the publication on various levels. We thank Freek Lomme for his backing, his inspiring words, and interest in our work, colorlibrary.ch for their great color profiles, and our sponsors for their support. Moreover, we thank Chloe Stead and Dylan Spencer-Davidson for editing texts at different stages and everybody else who showed interest, patience, and curiosity for our project.

A.R. practice (Ann Richter & Agnieszka Roguski)

In Other Words, Please be True

Photography and Indexicality's Persistent Promise

Melanie Bühler

Photographs have long been praised as the kinds of images that are the most immediate, direct, and truthful. Following the argument, perhaps most famously articulated by André Bazin,[1] that as imprints of light they directly reflect what is out there and thereby circumvent human interfer- ence, they have been heralded as pure im- prints of reality. Whilst this was arguably never truly the case—an image is always the product of a human intervention, however minimal—the introduction of digital technologies has further undermined the validity of this statement. Photography is, now more than ever, a layered process in which the photographic moment merges with all kinds of other processes, applications, and protocols, resulting in a hybrid format and an array of possible "visualizations."[2] With the rise of the internet and social media the status of the image has also changed: shifting from the emphasis on the single, static image to a set of image relations.

1 André Bazin and Hugh Gray (trans.), "The Ontology of the Photographic Image," in *Film Quarterly* 13, no. 4 (Summer, 1960), 4–9.

2 Peter Osborne, "Infinite Exchange: The Social Ontology of the Photographic Image," in *Philosophy of Photography* (London: Verso, 2013), pp. 59–70.

Nevertheless, the contemporary photographic image in all its networked modularity is still treated as a classic analog image in the sense that specific values connected to the idea of indexicality continue to inform how we interact with images. In specific ways, the idea of a special, indexical relationship between the image and its referent continues to live on, even though it is clear that this relationship has been disturbed by filters, manipulations, software applications, tags, and other technologies of modulation.

55

Indexicality, in this sense, has diffused into a set of expectations and rules connected to certain image genres as they have evolved as part of online culture. This clinging to traditional photographic values is exemplified in different ways in two image genres that have emerged in recent years: the 'selfie' and the installation shot (the current way to document exhibitions). Whereas with the selfie the traditional photographic values of immediacy and intimacy live on, the installation shot stresses the photograph as an objective, representative image to the extent of having erased all traces of human involvement.

The selfie can be regarded as a prime example of what Sven Lütticken calls "general performance";[3] the current normalized imperative to work on our lives while living to/through work. Everything we do can potentially turn into a future investment, given that opportunities can arise at any moment as long as you make sure you are present and connected. Seen from this perspective, the selfie assures us of our networked presence. It proves that you are there, looking good and ready to be part of the image flow by contributing your most essential assets, your face and body—eager for recognition, likes, and shares. The selfie has become the most common representational image format online in the ambivalent reality of the internet, marked by the inability to properly distinguish between labor and leisure, producer and consumer, and using and being used. Immediacy and intimacy are key features of the selfie. In order for a selfie to be successful it needs to be personal and authentic. Defining the genre is a craving for the intimate relation between the device and the depicted subject, usually the owner of the device. This is literally exemplified by the distance between the device and the subject; the camera is always no more than an arm's length away from its subject (unless taken with a selfie stick, but even then the camera remains relatively close to its subject). The value of the selfie is directly connected to the intimacy and associated authenticity it suggests, despite the fact that this image genre is highly stylized and follows distinct aesthetic patterns and rules.

This is made apparent by *Excellences & Perfections*, a recent project by Los Angeles, London, and Gijon-based artist Amalia Ulman. Starting in the spring of 2014, the artist regularly posted images of herself on her Facebook and Instagram accounts. The images exclusively refer to a specific aesthetic sensibility and tone: a seductive, erotic girliness in cream-colored shades. As she continued to post images, a narrative started to unfold with Ulman presenting herself as a young woman in LA drawn to expensive brands and luxury. The pictures show the artist with shopping bags, lingering in bed, presenting her body in underwear, trying on outfits as she allegedly gets ready for dates—against a backdrop of hotel rooms, lobbies, elevators, and bathrooms.

3 Sven Lütticken, "General Performance," in *e-flux journal* 31 (January, 2012): http://www.e-flux.com/journal/general-performance/

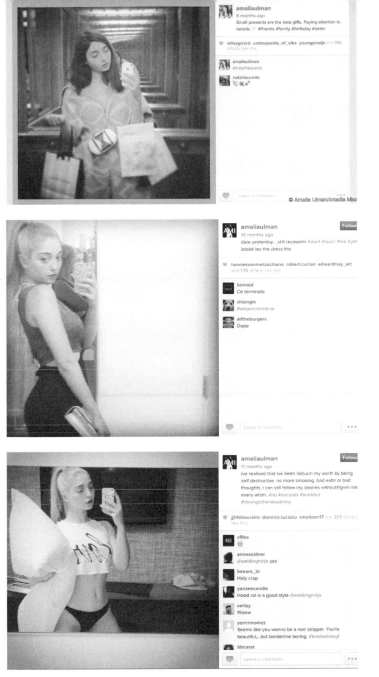

Amalia Ulman, "Excellences & Perfections," 2014, performance on Instagram.

After a period of four months and having reached more than 60,0000 followers in the process, the artist revealed that the project was a staged performance, an artistic intervention in which she made use of her social media accounts to present the fictional narrative of a young woman.[4]

While this project is ripe with controversial content that comments on how (female) subjectivity and embodiment is currently presented, branded, and valorized online, Ulman recently told me that the single thing that upset her followers most was the fact that her image feed was staged. Undermining the essence of the selfie, which is to say the sacred link between proximity, intimacy, and truth-as-correspondence, was apparently an act judged more shocking and offensive than any affront to the heterosexist male gaze or to capitalist (self-)exploitation could ever be.

The desire that the photographic image be truthful and authentic is thus especially pronounced in the kind of self-confessional pictures that dominate our image feeds. Moreover, it is also increasingly demanded by the platforms that organize, contextualize, and proliferate the images posted online. Facebook and Instagram want us to identify ourselves in a way that can be visually coded into a well-defined consumer profile. According to their business models, uploaded images make up an important part of the daily information flow that generates their advertising revenue. Identity, by this logic, is tied to a profile that can be linked to consumptive patterns in order to target us more precisely in the future.

In her performance, Amalia Ulman stages herself as a "mediated subject of capitalism, that is a subjectivity thoroughly entangled with the technologies and economic structures"[5] of our time, as the London-based artist Erica Scourti recently theorized in reference to a strand of artistic works to which Ulman's performance could be connected. Within this performance, the photographic image—and especially the selfie—plays a crucial role as an agent for immediacy, intimacy, and truthfulness.

5 Erica Scourti, *The Female Fool: Subversive Approaches to the Techno-Social Mediation of Feminity*, MRes Art: Moving Image, Central Saint Martins College of Art and Design, University of the Arts London, June 10, 2013. https://www.academia.edu/4029840/THE_FEMALE_FOOL

Referring back to Bazin's description of the expectations towards a photograph with regard to its authenticity, it becomes clear that in the age of the digital image, Photoshop, and Instagram, this attitude has not changed significantly, especially in regard to the selfie: "The objective nature of photography confers on it a quality of credibility absent from all other picture-making. In spite of any objections our critical spirit may offer, we are forced to accept as real the existence of the object reproduced, actually re-presented, set before us, that is to say, in time and space. Photography enjoys a certain advantage in virtue of this transference of reality from the thing to its reproduction."[6] The point to make here is: Despite the increasing malleability of the digital image and the growing importance of the relation between images, the example of the selfie shows that its value is still largely derived from a belief in the direct, authentic, and truthful relation between the image and its subject. This is further emphasized by its socio-technological framework, in terms of temporality (the speed with which it can be uploaded and the directness this suggests),[7] in terms of

6 Bazin, 8.

7 This is also stressed by the platforms that circulate selfies. Instagram, for instance, always indicates how long a picture has been posted.

proximity (the physical distance between device and subject), and in terms of context (Instagram and Facebook connect the images to the specific, standardized profile of an existing person).

The installation shot can be seen as a second example as to how traditional values associated with the classic photographic image continue to live on as part of online culture.

With the installation shot that documents contemporary art exhibitions, a specific image genre has emerged that builds on another traditional photographic value: the image as an objective imprint. In recent years, a specific pictorial genre has surfaced for presenting exhibitions online. Most frequently the artworks in such an installation shot are set against a white, pristine background. The image bears no traces of human presence, is perfectly lit with artificial light and shot with a wide-angle lens. This specific aesthetic has been featured especially prominently on Contemporary Art Daily, probably the most important online image blog dedicated to presenting art online. Beyond this blog, this kind of image has also become increasingly pervasive elsewhere, as the way to successfully show art online.[8]

8 The role of Contemporary Art Daily and the properties of the installation shot have been brilliantly contextualized and theorized by art historian Michael Sanchez: Michael Sanchez, "Contemporary Art, Daily" in *Art and Subjecthood*, edited by Isabelle Graw, Daniel Birnbaum and Nikolaus Hirsch (Berlin: Sternberg Press, 2011).

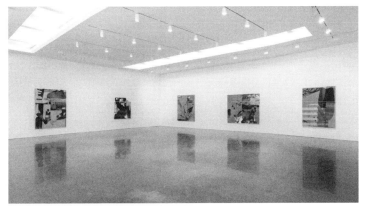

Alex Hubbard at Regen Projects, Los Angeles.
Installation view from Contemporary Art Daily, 2020.
contemporaryartdaily.com/2020/01/alex-hubbard-at-
regen-projects/

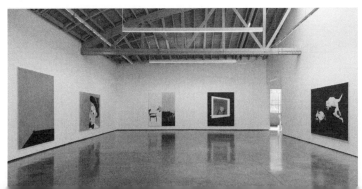

Calvin Marcus at David Kordansky, Los Angeles.
Installation view from Contemporary Art Daily, 2020.
contemporaryartdaily.com/2020/01/calvin-marcus-
at-david-kordansky/#288628

Translating the aesthetics of the White Cube into a pictorial composition, these photographs would like to make us believe that no human has ever touched these perfectly retouched images. They show no stains, no blemishes, no bodies, just works, well lit against a backdrop of pristine white. As such, and by removing all the worldly, bodily, potentially dirty, or otherwise imperfect traces of our daily lives, these images create the illusion of absolute objectiveness.

In doing so, they seem to represent pure objects, void of human interference between the object and its representation, a quality that traditionally has been attributed to analog photography. By smartly staging art objects in front of a lens—using proper lighting, positioning the works against a white backdrop, and choosing the right angle—and then digitally enhancing the objective properties of the image—by taking out blemishes and shadows, enhancing color contrasts etc.—this photographic value becomes a set of aesthetic properties enforced by digital means. Interestingly, a quality that is linked to the technical properties of an analog photograph—the direct, objective imprint of light on paper—now becomes aestheticized. Even though we might know that these images have been retouched, stylized and worked on, we still accept them as documents, desiring and having internalized that which the photographic image continues to stand for: objective truth. Going even further, these images can be read as the amplification of the objective properties Bazin describes: "For the first time, between the originating object and its reproduction there intervenes only the instrumentality of a nonliving agent. For the first time an image of the world is formed automatically, without the creative intervention of man."[9] Ironically with the installation shot, the effects produced by the nonliving agent have intensified, although they are now created by human beings; the aesthetic effects that further enhance this non-human status and these objective properties are indebted to the human labor invested in these images.

9 Bazin, 7.

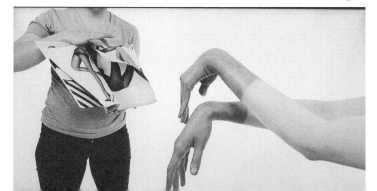

"When seeing an image of an exhibition, we assume that what
we see is the documentation of an actual event—a shared
and witnessed reality."
Quote and screenshot from "Soy Disseminated"
by Rebecca Stephany and Nora Turato, 2014.

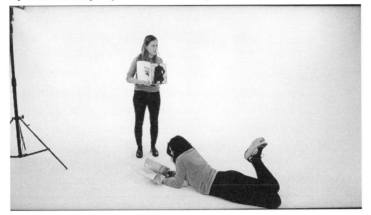

"In digital photography, any lens shorter than 15 mm is
considered ultra-wide. Shot with an ultra-wide lens,
a living room becomes a reception hall with tiny benches,
an exhibition space becomes a cathedral with tiny dots."
Quote and screenshot from "Soy Disseminated"
by Rebecca Stephany and Nora Turato, 2014.

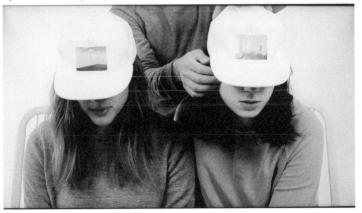

"LED lights, we don't do spotlights"
Quote and screenshot from "Soy Disseminated"
by Rebecca Stephany and Nora Turato, 2014.

10 Michael Sanchez makes this point explicit when he describes how the lighting installed in spaces was specifically chosen to mimic the glow of the screen: "These galleries all employ a large number of high-wattage fluorescent-light fixtures, as opposed to more traditional spot lighting, making their walls pulsate like a white IPS screen (the now-ubiquitous LCD technology introduced by Apple in 2010)." Michael Sanchez, "Art and Transmission" [2011], *Artforum* (Summer 2013).

The reality produced by the installation shot feeds back into the actual staging of artworks in gallery and exhibition spaces. Aiming to mimic the aesthetic that has been proven to circulate images online so successfully, the installation shot influences the way objects are presented as part of exhibitions.[10] As

such, it exemplifies what Vilém Flusser described some thirty years ago: "Instead of representing the world, they [images] obscure it until human beings' lives finally become a function of the images they create. Human beings cease to decode the images and instead project them, still encoded, into the world 'out there,' which meanwhile itself becomes like an image— a context of scenes, a state of things... The technically produced images that are all around us magically restructure our reality resulting in a global image scenario."[11] The image scenario created by the installation shot in physical exhibition spaces. As such, exhibiting works in galleries and other venues becomes a function of feeding back into the online image stream of documentation shots, further enhancing the 'truthfulness' and objective quality of these images.

11 Flusser, Vilém, *Towards a Philosophy of Photography*, 10. London: Reaktion Books, 2000.

When considering the installation shot and how the value of objectivity continues to inform this particular image genre, one can observe objectivity as being enhanced and intensified in a twofold manner: firstly, through an aesthetizication (digital enhancement) of its defining properties and secondly through the dynamic produced from the reality created by the image. Despite the fact these images become objectively less objective, their effects would like to make us believe exactly the opposite.

Just like with the selfie, then, truthfulness as a value inherent to photography lives on, despite and—paradoxically—also enhanced by the fact that the photograph's direct relation to the object has been layered by human interference and digital manipulation.

Subjective Exposure

Becoming Visible within a Networked Perspective

Agnieszka Roguski

Portfolios, websites, social media—exhibitions everywhere seem to be opening up digital avenues. Or are the avenues provided by the Internet reopening the exhibition? With the digital transition, everything that has been executed during the historical development of hegemonic exhibition architecture (the White Cube), every movement, touch, or even use, seems to become globally and virtually accessible. Is this the era of the showcase-to-go?

Indeed, the constant availability of exhibitions captivates less in auratic moments of individual contemplation than by their access via 'views' (a term that effectively blends contemplation and opinion). The fact that these views follow a seemingly objective logic correlates to a net-culture, which has long since ceased to view Cyberspace as a sphere of virtual masquerade but rather as a transparent concept of communication.[1] This mostly results in contradictory modes of exhibition displays: The flat, digitally circulating image that refers to creative depth and uniqueness. But whose view is being shown anyway?

Primarily, it would seem that the media technologies themselves are out of sight. Their touch screens and instant messaging suggest a directness that allows their users to forget they are even using a medium. This very experience of immediacy is, however, an effect that arises from indirectness—the usage of media and cultural technology. The simplicity of a very objective surface aesthetic enables the using subject as well as the used hardware to disappear. In the digital realm, contact with art occurs within contexts that may be appropriated by the user: on platforms and via applications. Here, the arranging of a certain order or socio-visual infrastructure is decisive—both in respect to the personal interface design, as well as the exhibition views that appear within it. Only then can connections be established that refer to a network of relations from which the subjective relationship ultimately emerges. Therefore, I would argue that these installation views produce 'subjective meaning' as

1 In 2013 Apple replaced its skeuomorphic (imitating the design of familiar objects) design with a flatter, clearer visual identity. As the internet became more familiar, organically designed surfaces, shading and other 3D effects that were supposed to connect the mobile interface with analog technologies and objects (such as notebook bound in leather) were no longer neccessary.

63

an effect that appears in variable relations. Consequently, I understand subjectivity to be a reciprocal principle that is articulated in a specific manner within the installation view. But how is it possible to make something comprehensible as a unique, subjective principle that circulates in pictorial concatenations? And, most of all, what does a subjective view mean when it appears with an objective aesthetic?

With the title *Subjective Exposure: Becoming Visible within a Networked Perspective,* I am alluding to the (contemporary) interpretation of subjectivity, which is characterized by creativity. This creativity is neither found inside the studio, shielded from the public eye, nor in the fleeting play of infantile fantasy. It has become much more visually measurable and conveyable as part of an exhibition space, which causes the exhibited art within—and its subjective compositions—to step behind its "enhanced presence."[2]

2 Brian O'Doherty, Inside the White Cube, 9. Berlin: Merve, 1996.

The perspective that takes all this into consideration is, according to Brian O'Doherty, a product of Modernism—and therefore also bears witness to the era he describes as the "disappearance of the perspective."[3] This sounds almost impossible and yet plausible: The invention of perspective is seen by the French philosophers of post-structuralism such as Lacan and Foucault as a frame that organizes the subject, turning it into an index for what is here or there, familiar or unknown. Originally, perspective was geometrically aligned; the subject's point of view obeyed the laws of optics.

3 Ibid., 39.

Perspective, however, also expresses that beyond what is visible: It articulates the relationship of the seen to the self. What becomes visible within an image, mostly by way of consistent constants and norms, converges outside the image through the subjective connection to a point, which is ultimately called perspective. This creates subjectivity via difference: the personal point of view turns the observed into something different. In the digital age it is this very difference that has been newly occupied. Subjectivity is, therefore, no longer associated with geometry, but with uniqueness, freedom, and individuality, embodying the idea of a creative self, whose view of the world always finds new modes of expression for the perpetually same. Thus, perspective—and all forms of 'views'—acts as a paradox concept; it seems to be as universally measurable as it is individual.

But why speak of a disappearing perspective at all? Let's take a look into the past: For subjectivity, individuality and art are ideological formations that are deeply entangled with European Colonialism, Industrialization, and the rise of Capitalism. When Portuguese fleets sailed to Africa in the early 15th century they were confronted with different modes of human experience and consequently developed the idea of the individual, which was constituted by the individual's closeness to God or the King—and subjectivity was experienced as the 'discovered.' The modern subject is, there-

fore, not just a product of art discourse but defines itself mainly through 'the other.' Eventually, this model of metaphysical hierarchy is replaced by the economic activity with the rise of the bourgeoisie. The individual finds its resemblance in the figure of the artist where earthly labor and divine creation are one. In the 19th century, the mathematically oriented central perspective of the Renaissance encounters a new concept of the observer: Observing is attributed to a privileged position. A paradigm shift from geometrically to physiologically experienced optics occurs—vision itself becomes a protagonist.[4]

4 See Jonathan Crary, *Techniques of the Observer. On Vision and Modernity in the 19th Century*, 19. Dresden and Basel: Verlag der Kunst, 1996.

That this perspective has now 'vanished' isn't due to a lack of consistency in visual parameters. On the contrary, it is precisely the installation view that is striking in its geometric perfection and reduction to basic architectonic components. Yet today's perspective is still ascribed to the concept of the subject that no longer belongs to a static order. A possible subjective perspective that is made visible in installation views would thus express itself as an individual relationship to the exhibition—even if these images might look (nearly) the same. This relationship ultimately refers to the identity of the individualized subject, who finds oneself in the highly technological world of today's capitalism. The subject's perspective is controlled by neo-liberal economies that regulate and form one's view. Taking this idea radically further with technology-philosopher Maurizio Lazzarato, the individual virtually becomes an object, part of the infrastructural layout of financial systems, the welfare state, and public institutions such as hospitals, schools, and museums.[5] Today, it is not just museums that represent the "institutions of the visible"[6] and form our ways of seeing—the Internet does so as well. To become a subject is therefore contingent upon the relationship to a system of objects—as generated by exhibitions and install views—and, especially in regard to digital image media, may only be conceived in correlation with them.

5 Maurizio Lazzarato, "Neoliberalism and the Production of Subjectivity," in *Libia Castro & Ólafur Ólafson. Under Deconstruction*, ed. Ellen Blumenstein, 35. Berlin: Sternberg Press in collaboration with the Icelandic Art Center and the National Gallery of Iceland, 2011.

6 Tony Bennett, "Der bürgerliche Blick. Das Museum und die Organisation des Sehens," in *Die Ausstellung. Politik eines Rituals*, ed. Dorothea von Hantelmann, Carolin Meister, 47. Zürich, Berlin: Diaphanes, 2010.

As such, the "image effect of the perspective"[7] may be decisively broadened, especially in regard to its approach: The subjective view paradigmatically supersedes the geometrically defined perspective. What, initially, constituted a clear relationship of the self to God or the divine regime of the King, later describes the relation of the self to its own creativity. As "entrepreneurial self"[8] it performs in a representative economy that asserts itself in the exchange of creatively produced objects. With the emergence of contemporary art, this very economy generates references to the self that can no longer be framed as uniform, static perspectives,

7 Marius Rimmele, Bernd Stiegler, *Visuelle Kulturen / Visual Culture zur Einführung*, 43. Hamburg: Junius, 2012.

8 Ulrich Bröckling, *Das unternehmerische Selbst. Soziologie einer Subjektivierungsform.* Frankfurt am Main: Suhrkamp, 2007.

but describe a paradox set of relations and interpretations. This is because, especially since Marcel Duchamp, creation is no longer treated as the exclusive product of artistic genius: "The creative act is not performed by the artist alone; the spectator brings the work in contact with the external world by deciphering and interpreting its inner qualification and thus adds his contribution to the creative act."[9] A subjective perspective encourages the interpretation of the audience, which is also the case for the daily language of mass media. As a result, contemporary art has brought forth a subjective view that is bound to participation, access, and consumption and comprehends the viewer, consumer, and citizen as a liberal, autonomic individual.

It is, after all, the figure of the creative individual who organizes and arranges all that may be understood as subjective view and also—or precisely therefore—appears in the supposedly objectively designed areas such as the installation view. Therefore, the created view of the creative artist, which was once essential for the subjective perspective, finds itself in a state of dissolution, or rather amplification. No longer uniformly created, it is released into "social, economic, and discursive frameworks" and finds "its realization in the figure of the curator—in its ever relationally defined role."[10] Thus, subjectivity obtains a kind of spectral perspective. Less focused on a single work than on a set of roles and contexts, it incorporates the relations of audience, institution, artist, and curator as a "temporary constellation."[11] Installation views, in particular, illustrate this transition. The fact that these constellations are transient—the exhibition disappears and the documentation itself may be reproduced but not repeated—creates variations and differences within this visual paradigm, designed for legibility. Therefore, that which is viewed online, appears both standardized and a freely selectable view: The contents may be visually arranged according to one's personal surfing tendencies and in a sense curated; in windows, feeds, or virtual tours. This arranging of contexts simultaneously exposes and constitutes the subject, becoming invisibly visible in the installation view.

Hence, the autonomic individual constitutes the center of an arena of views that has one essential feature: It is self-referential and knows no inside or outside. It is the network's logic that converts all the different codes within an image to one singular perspective. The net is thus not only a metaphor but also a type of logic; it influences a world based on connections and variations in such a way that all which is outside disappears in favor of a "boundless economization."[12] Only this invisible view comprises the value of the installation view—it increases with the quality and quantity of connections.[13]

Agnieszka Roguski

9 Marcel Duchamp, "The Creative Act," in The Writings of Marcel Duchamp, 140, ed. Michel Sanouillet, / Elmer Peterson. New York: Oxford University Press, 1973.

10 Luc Boltanski, Ève Chiapello, quoted from: Tom Holert, "Formsachen. Netzwerke, Subjektivität, Autonomie," in Kreation und Depression. Freiheit im gegenwärtigen Kapitalismus, 130, ed. Christoph Menke, Juliane Rebentisch. Berlin: Kadmos, 2010.

11 I prefer not to go further into detail on the question of value, which arises in connection with online forums. Of significance, however, is that 2008 was the founding year of the well-known blog Contemporary Art Daily, which became famous for its publication of standardized installation views. 2008 is also the year the stock market collapsed and social media expanded significantly. All of these aspects have generated effects that mutually depend on and complement each other—and have thus generated specific standards.

12 Magdalena Nieslony, in response to Michael Sanchez in Art and Subjecthood, 63, ed. Isabelle Graw, Daniel Birnbaum, Nikolaus Hirsch. Berlin: Sternberg, 2011.

13 Michael Sanchez, "Contemporary Art, Daily," in *Art and Subjecthood*, 54, ed. Isabelle Graw, Daniel Birnbaum, Nikolaus Hirsch. Berlin: Sternberg, 2011.

Michael Sanchez goes as far as to claim that the artworks themselves are evolving into "social networking devices,"[14] because the objects within the installation views circulate as in group shows. The installation view becomes the presentation of a profile—and the art blog becomes the place "where images go to network on a newly expanded scale."[15] Thus, the Internet is ruled by a feedback-structure, which contains the network as a dominant contemporary paradigm and keeps all the personae that appear within it—artists, curators, and viewers—in constant action. The fact that these connections are based on the ideal of European and North American art institutions and galleries is worth mentioning.

14 Ibid.
15 Ibid.

When a subjective perspective is articulated, it describes not an isolated setting, but a junction within a media network. Exhibition views seem to create a space in the infinity of a newsfeed that may not delve into the depth of physical places, but into a vastly growing connectivity. The structure of the display is, therefore, an exhibition *and* an interface, the expression of a "networked sociality,"[16] which refers to the figure of the creative self or 'free' subject.[17] The dimension of autonomy and freedom that resonates here, has, however, eroded. It is bound to a subject that, as a "formulated structure," is an unstable and productive figure and is in a "process of continuous reinvention."[18]

16 José Van Dijck, *The Culture of Connectivity. A critical history of Social Media*, 5. Oxford, New York: Oxford University Press, 2013.

17 As early as the 1980's the Company Apple has advertised the Macintosh Computer as a possible empowerment strategy for users who wish to realize "expressions of the true self" (Ibid., 10).

18 Tom Holert, *Regieren im Bildraum*, 134. Berlin: b_books, 2008.

In conclusion, the aura of exhibitions, once sought out in direct presence and originality, is now produced in a novel way on the Internet; not just in the image, but via effects within the image on an audience of views that creates a setting for it, shares it: The network of the art world. The multitask-profile of "networking subjectivity"[19] that arises thereof, no longer reveals its perspective by offering insight into a creative interior, instead it looks much more towards an outside that is in constant interaction with the self. Categories for the objective and subjective become equally redundant because autonomy—and thus the boundary between object and subject—doesn't exist within the network. An interesting reaction would be to not consider subjectivity as, in the sense of a dematerializing artwork, lost, nor to appreciate it as an individual perspective, but, instead, to reevaluate this view in regard to the reputed 'others' (and the accompanying factors of race, class and gender)—as a networked rather than a singular perspective.

19 Ibid., 42.

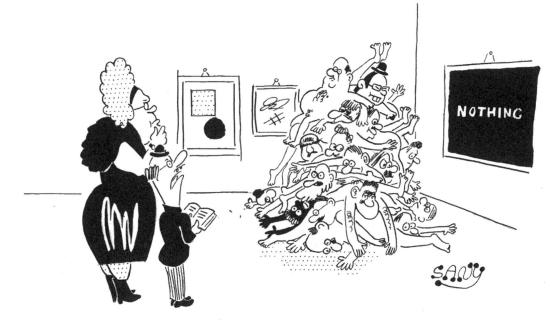

-Perhaps it should have remained on the discourse level?

Professionalized Reenactment

Erika Landström

It has been suggested that the use value of the art object lies in its potential to appear as pure exchange value, and that an art object (such as a painting) contains stored labor as artistic production. Similarly, an institution or gallery might contain stored labor as reproduction, distribution, and circulation of art objects. In the case of performance developed for and in the institution or the gallery, its reproduction, distribution, circulation *and* production (in some cases *as* production) are stored in the site, that is, in the institution or the gallery as art object itself—though not necessarily *on* site. In the same way that the labor stored in the art object might be recalled to presence as it performs as exhibition piece, archival object, or collectable, the labor stored in the institution or gallery can be recalled to presence in performance. In turn, the labor stored in the institution or gallery—itself a quasi art object—is recalled to presence in the circulation of still and moving photographic images, sometimes referred to as "documentation" (a questionable term). Furthermore, performance developed in the institution or gallery expropriates the institution or gallery as site—it is an artistic production or cultural commodity that itself commodifies through territorial and occupying activity, capitalizing on spatial potential.

A practice that combines performance with the making of art objects seems more speculative than a practice encompassing either performance or the making of art objects. The potential of stored labor to be recalled to presence is doubled in a performance performed live as production in the

69

institution or gallery (adapted, unique, and responsive to site-specifics such as architecture). When combined with the production of art objects, such as paintings made either on-the-side or during the performance (painting as 'merch'), the potential is threefold. Since an artist could perform several times at different locations—each performance a time-spatial variation and therefore unique—multiple spatial instances can be acquired, laying the groundwork for a reciprocal relation between the performance artist and the institution or gallery. The artist's production as territorial expansion through appropriation and expropriation of site stands in direct relation to the institution's visitor numbers and the art object's exchange value.

If the fundamental structures of social abstraction are to be found in the commodity-form—in this case, the art object—and its introduction to a social sphere through principles of exchange, a formal analysis of the art object should entail productive labor as well as abstract or cognitive labor (as reproduction, distribution, and circulation). Cognitive labor centers on reflexive procedures—organizational codifications of production, flexible accumulation to which there is no inherent or organic limit of magnitude—rather than commodity production or exchange. If perceived as productive labor, the products of abstract and cognitive labor are transient. For this reason, a formal analysis of the art object should concern its assumed limitations, concrete as well as abstract.

While performance is inevitably subjected to principles of exchange, the primary focus of its discourse is typically not the art object as commodity-fetish. However, in appropriation and expropriation of site, as when performance is performed and produced in the institution or gallery, sites are circulated as commodities signed by performativity. A performance produced live in the institution or the gallery affirms a specific articulation of difference, at the same time as it realizes the fact that the real of its abstraction is an absence of determinations—the institution or gallery as neutralized and normalized background, purged of historical and cultural content, coupled with its own immortality through reproduction, distribution, and circulation.

Art objects are not reified solely as contained form or site, but as open-ended and adaptable frameworks of circulation, which can be considered both their limitations and delimitations. Performance does not only inhabit the framework of the institution, gallery and apparatus of reproduction, distribution, and circulation as art object, but reflects this framework within its own mechanisms as the reflexive character of processes of abstract, cognitive, and social labor. Through their reflexivity, live performances render the aforementioned framework of mediation and reification timeless, neutral, and stable—if not close to invisible. Whether consumed live or as reproduction, they seem to recall the notion of realism as materialism, punctuate illusions and sooth the anxiety of abstract labor and mediated

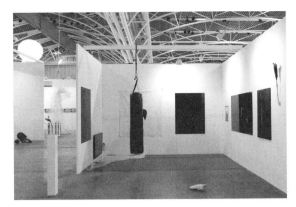

Anne Imhof, "Present Future section,"
Deborah Schamoni, Artissima, 2014.

experience. More so than other art objects, performance seemingly succeeds in making production 'visible,' and does so through aggressive appropriation and expropriation of authoritative spatial instances such as the institution or gallery—not only by appealing to notions of subjectivity through identificatory processes, as so often has been stated.

Apart from *The Work of Art in the Age of Mechanical Reproduction* (1936), Walter Benjamin articulated wider notions of the auratic, not necessarily reserved for the artwork proper. In *Little History of Photography* (1931), aura is defined as "a strange weave of space and time: the unique appearance of a distance, however near it may be."[1] In *On Some Motifs in Baudelaire* (1940), aura is what "invests" a phenomenon with the "ability to look at us in return," what "draws him [the poet] into the distance."[2] The "aura of the habitual"[3] or "experience that inscribes itself as long practice"[4] is mentioned, and in *One-Way Street* (1928), written during experiments with hashish, the concept of aura is associated with the psychophysiological state of rush or ecstatic trance, "for it is in this experience alone that we gain certain knowledge of what is nearest to us and what is remotest from us, and never one without the other."[5] In subsequent hashish fueled writings, Benjamin describes aura as ornament (*Umzirkung*), a "most hidden, generally most inaccessible world of surfaces," a "manifold interpretability."[6] Perhaps not far from the ornamental nimbus, aura is likened to a halo around the moon, or a court (*Hof*)—a space enclosed by buildings or walls open to the sky, or a social gathering around the king. Aura is coupled with a sense of untouchability, *Untastbarkeit*, with a veil that if removed, would rob the perceived of its essential character. Its waxing and waning is linked to dialectical oppositions of distance and proximity, subject and object, original and meditated experience, legibility and illegibility in social coding.

Considering these wider notions of the auratic, performance produced live in the institution or gallery might be understood as an auratic art object in and of itself—as a practice that reinstates the auratic—alternatively

1 Walter Benjamin, "Little History of Photography," in *SELECTED WRITINGS, VOLUME 2, 1927–1934*, ed. Michael W. Jennings, Howard Eiland, and Gary Smith, trans. Edmund Jephcott and Kingsley Shorter, 518. Cambridge, MA, and London, England: The Belknap Press of Harvard University Press, 1999.

2 Walter Benjamin, *Illuminations*, ed. Hannah Arendt, trans. Harry Zohn, 188, 200. New York, United States: Schocken Books, a division of Random House, Inc., 1969.

3 Walter Benjamin, *The Arcades Project*, ed. Rolf Tiedeman, trans. Howard Eiland and Kevin McLaughlin, 461. Cambridge, MA, and London, England: The Belknap Press of Harvard University Press, 1999.

4 *SELECTED WRITINGS, VOLUME 4, 1938–1940*, ed. Howard Eiland and Michael W. Jennings, trans. Edmund Jephcott and others, 337. Cambridge, MA, and London, England: The Belknap Press of Harvard University Press, 2003.

5 Walter Benjamin, "One-Way Street" in SELECTED WRITINGS, VOLUME 1, 1913–1926, ed. Marcus Bullock and Michael W. Jennings, English translation copyright Harcourt Brace Jovanovich, 486. Cambridge, MA, and London, England: The Belknap Press of Harvard University Press, 1996.

6 Walter Benjamin, "Crock Notes," "Protocols of Drug Experiments," in *On Hashish*, ed. Howard Eiland, trans. Howard Eiland et al., 81, 82. Cambridge, MA, and London, England: The Belknap Press of Harvard University Press, 2006.

delaying its decay. As enabled by the audience's real-time incorporation into the apparatus of reproduction, distribution, and circulation, the demolishment of the original through photographic reproduction is fed back into the performance as art object. Other than as a token of access, the labor of photographic reproduction endows spectators with a sense of artistic productivity as well as site-specific immersion demarcating the art object as time-spatially situated. In immersive performances, this process is embodied as a refusal of fixed spatial relations between the audience and performer, denying participants a sense of overview, sanctioning sequential positional views instead. This coercive internalization of the camera might provoke a psychological distance in spite of physical immersiveness, yet the restraints of photography and film—of the last decade—as a real-time time-based medium, return the audience to the production and reproduction of a 'here and now.'

> Live performance counteracts the remoteness typically attributed to reproduction with the presence of the performer (as performer, individual, or actor is of less importance) and a time-spatial uniqueness facilitating mobility without undermining originality. It is equally designed to counteract the decay of aura onsite, as it is to charge its reproduction with a transcendental transience. If the performer's countenance accounts for aura in the institution or the gallery, the faces and bodies of the audience reproduced and circulated, accounts for a reinstatement of aura in the art object reproduced. This objectification—in effect, commodification—of the reproduction and of what is being reproduced, redefines production and consumption as reproduction alike.

Benjamin's expanded definition of aura evokes a suspended dialectics, propelled and perpetuated by new sets of contradictions rather than synthetic resolution. If conceiving of aura both as liveliness and dialectical suspense, it might be relevant to revisit the readymade—not merely in terms of labor and authorship, but in terms of the subjecthood of the art object and the dialectical oppositions echoed in the commodity-form. The term readymade, as derived from the garment industry, already implies the manikin; the wearable; the human figure, and by extension, the art of display of early department stores and advertising. Correspondingly, the readymade in photographic reproduction might imply the portrait—replacing the subject or the individual, it is the commodity anthropomorphized, appealing to notions of phantom-like self-sufficiency and presence as stored labor recalled. Similar to the nominalist gesture associated with the readymade, performance produced and performed in the institution or gallery includes the appropriation and expropriation of site as background (frame, or support) for and in the circulated art object as photographic reproduction. The fetishistic impulse to free the figure of its background—as in the nominalist gesture where a specific commodity is acquired (and physically

brought in to the gallery, institution, or studio)—coincidentally meets with the impulse to anthropomorphize as well as the aforementioned impulse towards territorial expansion. Through multiple time-spatial reframings of the readymade, territory is expanded in terms of visibility and circulation of identified and objectified site. If repatriating the readymade to the portrait through photographic reproduction, and consummating the desire to fully anthropomorphize the object, the performer in a performance produced live in the institution or gallery could be considered a readymade itself—making it painstakingly clear that brand identity outlives individual identity.

The art object as readymade has often been discussed as marking a historical shift towards a textual reading of the artwork, from third-person address towards second-person address. In immersive performances, the spectator manipulation associated with second-person address, is more often carried out via the performer as readymade, rather than through captions or rhetorical direction. As part of the strategic reinstatement of aura, immersive performances seem to actively negate captions, enhancing the phantom-like objectivity of the performer as mute commodity-form, while maintaining and securing the second-person form of address in their circulated photographic reproduction. Seduced by images of exploitation, regular meetings with the gaze of individuals as anthropomorphized objects has become something like psychoanalysis on demand for the dominated dominating.

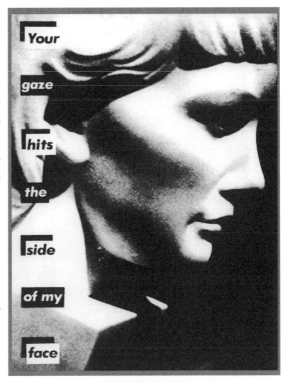

If seeking to evoke a general concept of subjectivity (rather than the representation of a specific subject), the performer as individual nevertheless summons agency, while the performer as representation of anthropomorphized commodity (the readymade), defers or assigns agency and authorship to a producer. This producer is both the faceless infrastructure of mediation (paralleling production relocated to low-wage countries) and the performer as individual, as well as the artist as curator and ultimate author of the performance as artwork. Commonly, this artist-author, more often than not an authoritarian, patriarchal figure, operates under/with the assumption that 'collaboration' liberates artworks from the ideological framework of the self.

Barbara Kruger, "Untitled (Your Gaze Hits the Side of My Face)," 1981.

Erika Landström

Live performances in the institution or gallery efficiently socialize capital through images of creativity, mobility, employability, and the nostalgia for embodied labor. In the current climate, professional performers often migrate from sectors such as theater, dance, and music to the government-subsided art institutions and commercial galleries. They seem omnipresent in performances where improvisation and choreography are consciously obscured and conflated. They mimic and abstract the demands of the free market, forging its simulation—subliminally seducing spectators through identificatory processes triggered by the performer as individual and ready-made alike. In this regard, live performances in the institution or gallery reenact and reproduce the precarious and exploitative labor-conditions within the culture industry.

If considering reproduction, distribution, and circulation as integral to the art object, the immersive live performance appears as a fragment of 'life,' and performance as an appropriation of 'life' itself. Signs representing signs—dislocated, overdetermined, contingent—come to rest upon larger systems of social meaning within codes of the domestic, the public, or more intricate social ornamentations. Often including several performers, immersive performances exploit habitus through mimesis, allegedly promoting relational readings over 'grand narratives' or 'great individuals.' They allude to the lived reality in which a targeted audience is socialized as individuals, in turn socializing spectators as interpassive participants. In employing performers as readymades—false subjects operating in the intersection of the technical and social—plausible relationships between performers as individuals are made indistinguishable from (in extent equalized with) staged relationships, destabilizing borders between spectator and performer. This image of intimate control, a control instance in itself, is often contrasted with gestures of liberation and figures of emancipation, where ideals of socially emancipatory art movements of the past such as the happenings of the '60s are recalled to presence as failed and repressed. In fusing the past with the present—ideas of the original artwork with procedural advancements within infrastructural space—immersive performances could be perceived as allegorical, even melancholic. Typical of the allegorical emblem is the suspension rather than the resolution of contradictions—a deferral generating discursiveness, at times perversion, since any type of critical discourse can be adhered to almost any art object or practice.

Supposedly negating conventional notions of medium-specificity and *l'art pour l'art*, time-spatial immersive performances are in some regards largely based on formalist procedures. Immersion as a physical or psycho-

Symposium: "Krise als Form. Revisionen zur Geschichte der Gegenwart," University of Applied Arts, Vienna, 2017. Photo by Enzo Shalom.

logical tool situates participants within a complexity that cannot be taken in at 'a glance,' where narrative succumbs to presence and seriality is suspended in multiple versions concurrently displayed. This free play of the signifier recalls the Kantian sublime as signifier without signified, as a bracketing of the referential function of language, as organized randomness. Holding contradictions in tension might politicize a practice, though in some cases, this tension is no more than a rhetorical tolerance coming to resemble populism. If the attempt is to liberate art from its increasingly problematic position as critical outpost or instrumentalized resistance, it is at the expense of critical distance, at the distinguishing of a critical staging from the mimicking of the free form of capital. When spectator manipulation ensures the accessibility of a work, but guarantees its misunderstanding, immersive performances are bound to cause a convenient (or 'constructive') ambiguity enabling the capitalization on a perpetual moment of crisis; crisis as critique, as content, as commodity. Meanwhile, the critique of the critique often stands and falls with the argument that in a loss of agency, one is obligated to *not* say what one means, awkwardly legitimizing convenience as subversive strategy or even tactic.

Merlin Carpenter, "The Opening," Reena Spaulings, 2007.

In some cases, it appears as if enough agency to exhibit a loss of agency, qualifies as critique in and of itself. Along with self-victimization, call-out culture, and habitual complaining, the loss of agency as critique suffices to generate the discourses legitimizing the culture industry's narcissistic desires. Disguised in various performances of inclusion and exclusion, proclaimed self-reflexivity as critique easily mutates into self-validation. If reflexivity is ascribed to performance, as previously mentioned, other practices such as those dealing mainly with/in painting and film can incorporate performance in order to efficiently convey self-critical attitudes. Performance in film, as estranged element dislocated from an imagined original context, exists in the absence of presence—physical proximity substituted by social. As differentiated from acting, performance in film has come to represent the 'documentary' as opposed to the 'fictional'—or at least function as a strategic tool in order to achieve an ambiguity of categories. When individuals perform rather than act, as in the case of

the cameo—when identity manifested outside the frame of the film (public personas or quasi-celebrities) is recognized within the frame—the notion of staged relationships is equalized with non-staged relationships. This moment of recognition, depending on the viewer's rapport to the performer or performance, provokes a sort of *Verfremdungseffekt*. Here, immersion is not physical as in live performance, but psychological. Critical distance is forcefully reinstated (rather than abolished), though not on supposedly "neutral grounds," but in the intimate zone of a viewer's social reality, exploited in and by the mimetic space of film. This type of implosion tends to bring out the abject in identificatory processes of socialization and subjectification. Such strategies exchange self-critique for self-exploitation; productive labor for reproductive, redistributive, and circulatory.

If photography has lost its truth-value, the circulated reproductions of immersive live performances seem to restore a referent. Photos and films, taken by the audience with the institution or gallery as background, seem to allude to the documentary, yet bypass the ethical complications ascribed to the genre, since authorship is 'democratized' and accredited to the apparatus of reproduction and circulation (rather than to individual agents). In the infrastructural space of circulation—itself neutralized—the neutral background of the institution or gallery seems to isolate 'subjectivity' as represented by single individuals (affective empathy) or performers as readymades (choice and exchangeability). These images stand out as a different form of indexicality, in which real-time speech-acts have replaced the physical trace as indexing sign. The authorship as-agency-as-subjectivity behind the lens on the other hand, is diluted, furthering the neutralization of the immersive infrastructures of circulation—as well as the desubjectification of the consumer.

Loretta Fahrenholz, "Two AM," production still, 2016. Photo by Till Megerle.

Contrary to immersive live performances, which augment illusions of transparency through formalities, film circulated (rather than produced) within the institution or gallery generally hides or flattens the conditions of its own production. Through the incorporation of performance (as differentiated from acting), the infrastructural space of reproduction and circulation is exposed as an integral part of the film as art object (voyeurism, tourism, social policing). As with most art objects, it is precisely the circulation within public institutions or galleries that set them apart as art objects in the first place. Yet the information needed in order to activate these films as discursive, can only be accessed on site if conceiving of the public institution or gallery as an extension of the art object, encompassing

infrastructural space of reproduction and circulation, reaching into the private. Reminiscent of the triumph (and downfall) of Institutional Critique, by pointing to the internalization or all-encompassing extension of the institution, the object of critique is debordered and absorbed.

In line with loss of agency as critique, 'the subjective' understood as 'the individual,' holds a privileged position, especially in socially engaged or socially concerned practices. In the field of identity politics, the testimonial has become something of a self-legitimizing maneuver, characterized by the violent and fetishizing act of cutting out speech-acts under the pretense of counteracting marginalization. When statements on "lived experience" come to serve primarily as vehicles for individual visibility, the testimony as document (a matter that provides information or evidence or that serves as an official record) is evacuated. A repressed objectivity is severing lived experience from social formations and historical context, eroding the testimonial, privileging (any kind of) nepotistic statements. The decentralization of the subject once associated with poststructuralist theory appears here as a new form of universalism, to which the particular shows itself as an empty slot. If not welcoming self-exploitation, artists are bullied into eroded versions of the testimonial as a safe-space, while academia—critics, theorists, historians—hold the fort of the objective, mastering discourses through the reenactment of critical jargon. The situation parallels the conditions of scientific research under neo-liberalism, where state and private funding of the applied science has escalated at the cost of basic science. Artists speculatively apply their practices to the market as commodities, while critics speculatively apply art practices to their theories, leaving little room for processes that might not always be intended as speculatively applicable.

This text was first published in *Intersubjectivity Vol. II. Scripting the Human*, edited by Lou Cantor and Katherine Rochester. Berlin: Sternberg Press, 2018.

Melanie Bühler

Melanie Bühler has been the Curator of Contemporary Art at Frans Hals Museum, Haarlem since 2018. Prior to this, she worked as an independent curator. Recent exhibitions include *Private Public Relations*, Pinakothek der Moderne (2017) and *Inflected Objects*, an exhibition series that took place at Future Gallery, Berlin; De Hallen, Haarlem (both 2016); and Swiss Institute Milan (2015). She is the founder and curator of Lunch Bytes (2010–2015)— a project on art and digital culture. She is the editor of *No Internet, No Art*, which was published by Onomatopee in 2015.

João Enxuto & Erica Love

João Enxuto and Erica Love are artists and writers collaborating on projects about how new technologies reshape work, institutions, and economies connected to con-temporary art. Together they were fellows at the Whitney Museum Independent Study Program and have presented work at the Centre Pompidou, Whitney Museum of Art, the New Museum, Anthology Film Archives, Walker Art Center, and other international venues. In 2017, they were awarded a New York Foundation for the Arts Fellowship and Creative Capital Andy Warhol Foundation Arts Writers Grant.

Calla Henkel & Max Pitegoff

Calla Henkel and Max Pitegoff have worked together since attending Cooper Union School of Art in New York. From 2013 until 2015 they ran New Theater in Berlin, where they wrote and produced plays with artists, writers, and musicians. They have shown their work at the Grüner Salon at Volksbühne Berlin; Kunstverein Hamburg; Cabinet Gallery, London; Spring Workshop, Hong Kong; and the Whitney Museum, New York. Since 2019, they have been running TV, a bar, performance space, and film studio in Berlin.

Erika Landström

Erika Landström is an artist living and working in New York. She attended the Whitney Independent Study Program 2018–19. Recent exhibitions and performances include *The Nature of Glove* at the Elizabeth Foundation for the Arts, New York; *May I Owe You?* at Schiefe Zähne, Berlin; *The Caucasian Chalk Circle* at Hannover Kunstverein/Sprengel Museum/Kestnergesellschaft, Hannover; *Now Change Your Name To Thief* at Liszt, Berlin; and *The Misanthrope* at the Montréal Biennial.

New Noveta / Yair Oelbaum

Artists Keira Fox and Ellen Freed formed New Noveta in London in 2012. Since then they have exhibited and performed extensively in Europe and the rest of the world. Themes of their work revolve around social conformity and behaviors within controlled societal structures and its effects, displaying anxiety, hysteria and forceful task-based actions in their performative behavior. Other subject matters and research have included folklore and witchcraft, the history of female alcoholism, and socio-political struggles on the body and mind and how this can manifest. They work within various mediums including sound recording and production, costume making and characterizations, prop making and installation building, as well as semi choreographing pieces for site-specific performances.

Yair Oelbaum is a social worker and artist based in Brooklyn, New York. His practice is interdisciplinary, encompassing photography, performance, sculpture, sound, and video. *There We Will Be Buried*, a theatrical performance by Oelbaum was performed at the Whitney Museum of American Art in New York City and the Institute of Contemporary Art in London in 2012. *Forerunner*, a film project with artist Kai Althoff was shown at Museum Ludwig in Cologne, Germany in 2017 and at the Nocturnal Creatures Festival presented by Whitechapel Gallery in 2018.

A.R. practice
(Ann Richter & Agnieszka Roguski)

A.R. practice is based on the conceptual and artistic collaboration of the designer Ann Richter and the curator and writer Agnieszka Roguski. Past projects include *Eine Frage der Form/Norm*, an installation within the exhibition *Returning to Sender* 2014 at HKW Haus der Kulturen der Welt in Berlin (2014), and *ON VIEW. w of digital and physical re-/presentations* (2015), an exhibition project that took shape online and at the art institution KV—Kunstverein Leipzig. At the core of their working method is the linkage of different practices. A.R. practice treats both designing and curating as mutual modes of thinking and doing from the very beginning of a project while traversing different types of visualities. Focussing on formats of visual display, they critically explore their ways of becoming public to create a fluid, entangled mediality. The work of A.R. practice has been widely presented in symposia and talks, such as at Louisiana Museum of Modern Art in Copenhagen (2015), Gropius Bau in Berlin (2016), the Städelschule in Frankfurt am Main (2017), the TCA Transcuratorial Academy in Phnom Penh (2018), and the HSD Hochschule Düsseldorf (2019).

Ann Richter is co-founder of Studio Pandan, an agency for graphic design and art direction, which specializes in visual identities and publications. Their clients include cultural institutions such as Bundeskunsthalle Bonn, Staatliche Kunstsammlungen Dresden, Guggenheim Museum Bilbao, and the magazine *Edit*. She also gives talks and workshops.

Agnieszka Roguski works at the intersection of curating and research. Her PhD thesis (FU Berlin) focuses on self-display under post-digital conditions. Her writing has appeared in *Texte zur Kunst*, *Springerin*, and *Spike Art Quarterly*, among others. She worked at PRAXES Berlin, CCA WATTIS, and the Academy of Fine Arts Leipzig, department for Cultures of the Curatorial.

SANY

"I'm Sany, a mixed-media artist living in Stockholm and working in Bremen. As a child I dreamt about being a comic artist. When I grew older I wanted to be a lawyer. Nowadays I find myself stuck somewhere in between law and slapstick." (Sany 2019) Sany is primarily occupied with low-culture stereotypes, borrowed from a cartoon world that flourished in Scandinavia from the 1960s until the 1980s. Apart from making cartoons, he is currently working on a philosophical enquiry that aspires to prove that images are bad.

Hanna Stiegeler

Hanna Stiegeler studied Roman Languages and Fine Art in Leipzig, where she completed her Meisterstudium, as well as at UdK Berlin and in Warsaw. In 2017 she participated in the Goldrausch Project for Women Artists in Berlin. She recently resided in Rio de Janeiro with a DAAD stipend. Her work mainly draws upon diverse historical and contemporary photographic material, and includes printings, textiles, texts, and installation. It focuses on questions of feminism, the realm of consumerism, psychology, and the surfaces of advertisement and fashion.

Jasmin Werner

Jasmin Werner lives and works in Cologne. In 2016 she completed her studies at the Städelschule in Frankfurt am Main. Her works have been shown in solo exhibitions at Salon Stuttgart, Berlin (2019), Kunstverein Braunschweig (2018–2019), Gillmeier Rech, Berlin (2017), as well as in group exhibitions at Kunstverein Ingolstadt (2019), Saloon, Brussels (2018), and the Folkwang Museum, Essen (2017). In 2017, Jasmin Werner completed a residency at the National Museum of Modern and Contemporary Art, Seoul and is currently a participant of the studio program at Kölnischer Kunstverein in Cologne.

Jonas Paul Wilisch

Jonas Paul Wilisch lives and works in Berlin, Germany. He studied at the Academy of Fine Arts Leipzig. He was nominated for the International Solo Award, Kunsthal Charlottenborg, Copenhagen in 2017, the Art Prize of Haus am Kleistpark Berlin (2017 and 2019), and the Berlin Art Prize (2013). He has received scholarships from the DAAD, Karin Abt-Straubinger Stiftung, and Kultur Senat Berlin, among others. His work has been shown at the European Media Art Festival, Kunsthalle Osnabrück, Kunsthal Charlottenborg, and BilbaoArte Foundation.

I didn't expect to stay here so long.